PATCHWORK

A Bur Oak Book

PATCHWORK

✳ Iowa Quilts and Quilters ✳

BY JACQUELINE ANDRE SCHMEAL

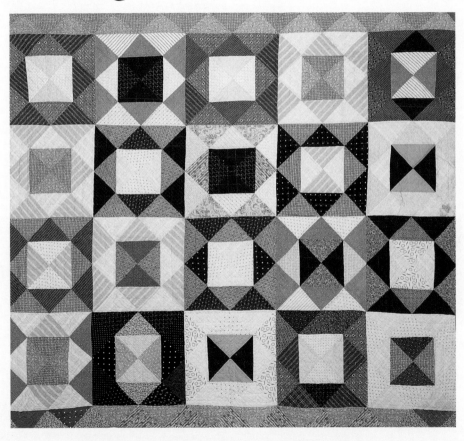

University of Iowa Press · Iowa City

University of Iowa Press, Iowa City 52242
Copyright © 2003 by the University of Iowa Press
All rights reserved
Printed in Singapore

Design by Omega Clay

http://www.uiowa.edu/uiowapress

The publication of this book was generously supported by the University of Iowa Foundation.

Printed on acid-free paper

Library of Congress Cataloging-in-Publication Data
Schmeal, Jacqueline Andre.
 Patchwork: Iowa quilts and quilters / by Jacqueline Andre Schmeal.
 p. cm.—(Bur oak book)
 Includes bibliographical references and index.
 ISBN 0-87745-865-0 (paper)
 1. Quilts—Iowa—History. 2. Quiltmakers—Iowa—Interviews. I. Title.
II. Series.
NK9112.S337 2003
746.46′09777—dc21
 2003042646

03 04 05 06 07 P 5 4 3 2 1

Contents

❋

Acknowledgments ix

Background Fabric xi

Dortha Asher

1

Elsie Noble Ball and Mary Ball Jay

11

Mary Premble Barton

21

Frances Brewton

33

Barbara Chupp and Salina Bontrager

43

Robert and Sadie Echelberger

53

Helen Jacobson

67

Ruth and Ivan Johnson

77

Ethel Taylor Jordan
87

Sara Miller
97

Winnifred Tyerman Petersen
107

Ruth Adams Steelman
117

The Sunshine Circle
125

Sources 133
Index 135

Acknowledgments

✳

SPECIAL THANKS to my grandmother, Alice Fox Andre, who launched my interest in quilts by giving me, at a young age, the appliquéd and embroidered "Seesaw Margery Daw" quilt which hung on a wall in my room. I gazed at it often, intrigued that my grandmother could create something so complex and alive. The quilt is now on display in a bedroom in the Farm House Museum on the Iowa State University campus.

Mary Barton, who has spent years collecting Iowa quilts and searching through magazines to get information on everything from pattern variations to stain removal, encouraged me to see beyond "just a quilt" by seeking the stories behind each one.

The library of the Museum of International Folk Art in Santa Fe, New Mexico, has been a source for many of the books on quilts that I have read throughout the years. My favorite is Ruth Finley's *Old Patchwork Quilts and the Women Who Made Them*. Published in 1929, the book reveals that Ruth Finley obviously cared passionately about quilts and had a great knowledge of them. Her information about quilts at an earlier time in America is enduring.

For me, quilts have always been like people, with their own names, fabrics, histories, and personally chosen stitches serving as autographs. My interest in quilts naturally led to an interest in the people who make them, so in 2000 and 2001, I conducted a series of interviews with quilters whom I learned of through exhibits, the Iowa State Fair, and the various quilters' groups across the state. I learned how entwined a quilt and its maker become. I learned about the amount of

work that goes into each quilt and the pride that goes into each stitch. I learned firsthand about the importance of quilting in the lives of quilters—past and present. The women and men who told me their stories are down to earth, hardworking, sincere, and dedicated to their art. They have quilted sometimes for income, sometimes for socialization, sometimes for warmth, and *always* for love of the art. I wish to thank all these quilters for sharing their stories and for heightening my appreciation of quilts and quilting.

Sadly, so many quilts—like many of those pictured in this book—become separated from their makers through the years. Sometimes an embroidered date reveals when they were made. More often, we must rely on the fabric and design to place each quilt within a time period.

Gratitude goes to photographers Rod VanderWerf and Addison Doty, who painstakingly photographed the quilts for this book—a difficult task because aging quilts invariably wrinkle, sag, and fade.

Appreciation to Robin Venter and the staff at the Grout Museum in Waterloo for their time and cooperation.

Thank you to my husband, Richard, who supports my fondness for Iowa and its people.

x

Background Fabric

※

THIS BOOK is the culmination of a lifetime's passion of caring for, learning about, and collecting Iowa quilts. For sixteen years, I owned a folk art store in Houston, Texas, where I sold Iowa-made carvings, folk paintings, cornhusk dolls, baskets, and quilts. I took special care with the quilts, making every effort to identify the designs and date them as accurately as possible. I have learned to use fabrics as guides to dating quilts. Those from the 1860s, for instance, often incorporate robin's red breast fabrics, while 1876 centennial quilts often have red, white, and blue fabrics, sometimes printed with little sports scenes. I also know that old stains on the quilts can reveal more about their history: blood stains can hint of childbirth, strawberry stains of a quilt's use in the garden during the summer months, and oil spots of years of storage in an old trunk.

From the mid 1800s to the present day, Iowa has been home to an active community of quilters. My Iowa-born grandmother, who quilted after the turn of the century, represents for me a link between the quilters of the nineteenth century and those of today. The somewhat frayed wool, velvet, and silk log cabin quilt she stitched at the turn of the century tells me about her as a person just as an old diary might do with words. The quilt is backed with a tired, washed-out blue and white cotton flannel blanket, yet the log cabins are pieced with the more expensive silks and velvets that I have learned were replacing calicos in midwestern fashions at the time she made the quilt.

Needlework was my grandmother's passion even when her stitches became jagged and imprecise as she aged. When she died in the 1950s,

my father stuffed her life's work of embroideries, cross-stitching, crocheting, and stitcheries into battered brown boxes and carried them on the Union Pacific from her last home, in Colorado, to our home in Ames, Iowa. Crammed into the boxes were three quilts: a brown cotton print Dresden plate, a pink and blue cross-stitch, and the heavy log cabin.

The quilts are a tangible part of the family chronicle. I look at the log cabin and wonder what Grandmother was thinking about when she stitched it. Where was she as she labored over it? Had she taken it with her when the family moved from New Sharon, Iowa, to Pasadena, California, in 1919, or did she make it once she arrived in the West? Are the fabrics from dresses she wore herself or from the dresses of friends? Was she happy as she stitched?

My grandmother never lived in a log cabin, but her choice of this pattern for a quilt suggests her close connection to the frontier. Born in 1877 in a big farmhouse overlooking New Sharon, she was a fragile child and was sent to Illinois to live with her apparently art- and music-oriented German-born grandmother. Perhaps this grandmother taught her to quilt and told her stories of the frontier, of log cabins.

In Iowa as well as the rest of the United States, quilting was almost as much a part of the rural home as canning or curing meat. It was generally the farm wife's job to provide bed covers, sheets, and other linens, a chore that many women found relaxing and creative compared to the rest of their grueling and monotonous chores. Iowa women, known for frugality, felt satisfaction from making use of their own scrap material. They also often memorialized friends by incorporating scraps from their old clothing into quilts. To make the bedding necessary to keep the family warm, every scrap and remnant of woolen material from garments was saved. From these pieces saved through necessity, many homemakers created intricate quilt patterns with fine stitches that today reveal their aesthetic sensibilities.

As settlers migrated west, they often exchanged quilt patterns, im-

proved on them, and worked out new designs to reflect their new environment. Quilters drew inspiration from nature, daily life, history, the Bible, and their own moods. With fabric and thread they illustrated the history of a new land. Settlers in Iowa, many of them immigrants, brought with them from the Old World memories of colors and designs that had been familiar. For instance, many Pennsylvania Dutch quilters who came to Iowa incorporated orange or yellow-orange colors into the designs that give them a special vividness and individuality as we look at them today.

Iowans have always been thrifty and sparing, and quiltmaking fit nicely into this habit, particularly while Iowa was being settled in the mid 1800s. Homemakers made quilts of substantial, serviceable material that was readily available and would withstand primitive washing methods and hard wear. Artistic elements were often subordinated in these earliest of Iowa quilts in order to make the best use of an old shirt or coveralls or other fabric remnant. During the late 1800s, autograph quilts became popular in Iowa. A group of neighbors would create a quilt for a bride, or a congregation would make one as a gift for the minister. Whoever pieced the block would sign it, giving this type of quilt particular historical value today.

At the turn of the century, when Victorian styles became the rage, women began using the best velvets and silks they could find to make crazy quilts. By the 1920s and 1930s, Iowa women translated everyday life into their quilt designs: Dresden plates, fans, wedding rings, flower baskets, and flower gardens. These designs could be made from scraps or pieces of feed sacks—a necessary adaptation during the Depression.

Women would often use the lonely winter months to piece together quilt blocks, then in the spring would invite neighbors over for a day of quilting, lunch and/or supper, and conversational "catch-up." Quilting has always been a social outlet for Iowa women, and it continues to serve that purpose today. At Bear Creek Friends Meeting

House outside of Earlham, the Sunshine Circle has been quilting together continuously since 1912. From generation to generation, the group remains a close-knit family sharing joys and sorrows, caring for one another. They have kept a diary of each meeting throughout the years; amazingly, the meetings haven't changed. The women have met, quilted, talked, eaten, and discussed what to do with their earnings for almost a century, and are still going strong. Near remote Fairbank, Iowa, in nearly any one of the big white Amish farmhouses, mothers and daughters can still be found seated around a quilt frame, heads bowed as they examine their stitches. For these and many other Iowa women, making quilts has been a way of earning a modest income in addition to serving as a social outlet.

*

Old quilts are personally created and signed gifts from quilters of the past, many of whom were braving hardships as they sought a new life in a new land. We need to respect and preserve these material artifacts of the past. Even though Iowa quilts were created to be sturdy, they suffer from the stress of continued washings. They have been stained from strawberries gathered in them, from the blood of mothers giving birth on them. They have been stored in musty old trunks; they have been used as the batting for newer quilts; they have been used to cover everything from furniture to farm equipment. I once found one that was oil-soaked from covering the engine of a tractor. It took a week of repeated washing by hand to remove all the oil.

The most recent misuse of old quilts is the fad of cutting them up to make teddy bears, tablecloths, or dolls. Many of the lovingly made quilts being abused in this way—even those with holes, tears, and stains in them—could be preserved or even restored so that future generations can learn to understand the hard work that went into making them.

Iowa quilters in the twentieth and twenty-first centuries can also help us understand quilts and quilters of the past. Many learned quilting from their mothers and grandmothers. The women and men who tell their stories in this book all made quilting a central part of their lives—often in spite of hardships, family obligations, and other work. Their individual stories form a kind of quilt block in words, each set against the background fabric of the history of quilting in Iowa.

PATCHWORK

Dortha Asher

✳ DORTHA ASHER'S father was a coal miner and tenant farmer near Moravia in southern Iowa. There were seven children and three adults in the family; money was scarce. But quilts and quilting, in their comforting way, have always overpowered any money worries.

"We moved every first day of March," recalled Dortha, a hands-always-at-work eighty-four, sitting in the living room of her Victorian cottage near downtown Albia. She sat in a well-used and comfortable antique chair, myriad spools of thread on either side of her, light from two windows highlighting her stitches and her busy hands. Next to her was an appliquéd quilt.

"Some of those houses weren't much," she continued. "We'd line a porch with cardboard and make a room. Mother could make a house livable with cardboard and wallpaper. I've been able to do that. I've remodeled houses, rearranged them, changed doors.

"It's a wonder I ever got any education. All my grade school life I went to a new school every March: Hamilton, Attica, Bussey, Marys-ville. We were poor, but we didn't know it. We had big gardens. We knew we didn't have what some people had. If we had meat once a day, we had it for breakfast. The men needed meat for their day's work."

Dortha's mother, who taught miners' children, always lined up four quilts to work on in the wintertime to replace those that had worn out. Dortha helped. "Even my dad would do chores and come in and help." She picked up a tarnished thimble from the little table beside her chair—the chair in the sunny corner of the room. "I have the thimble he used," she said.

Quilts were necessities as blankets and mattress covers. They were also decorative objects of pride. Lovingly remembering her mother, Dortha said, "She wanted to keep good quilts on the bed. We were taught to be very careful with all quilts, even when they got old. We didn't drag them around on the floor like kids do now. If we had a quilt we roughed around in, it would be one she made out of overalls that was tied with yarn."

At age nine, Dortha started sewing quilt blocks. Her interest in sewing soon expanded into regular family work. "I was going to have a new baby sister," she recalled. "I said, 'Mom, can't I help?' She told me I could hem diapers on the sewing machine. From that day on I kept sewing. I did practically all the family sewing—shirts, boys' overalls. My sister would say, 'I'll wash the dishes if you'll sew me a dress.'" Dortha would simply take an old dress and make a pattern from it. "At eleven I ran the sewing machine through my finger. I raised the needle out of it, but I had a sore finger. I learned the hard way. I didn't put my fingers under the sewing machine needle after that."

Dortha's first quilt, made in the mid thirties, was a snowflake pattern. She had ordered some material by the pound in order to make playsuits. With the tiny scraps, she made the quilt top, but she didn't get it quilted until the 1960s. "It took a long time to get it done. I was too busy," she said.

Dortha met her husband, Donald, on a blind date in Lovilia. After they married in 1935, he worked with his dad at a sawmill for a dollar per day. "If it rained, he didn't get the dollar," she said. "Money was scarce."

After her marriage, she made two appliquéd quilts—one for each mother. "We lived with my mother-in-law, and I had nothing else to do," she reminisced. "I had no money to buy Christmas presents with, and I could buy material for five cents per yard, so it was something I wanted to do."

She believes she copied her patterns from the wrappers of Mountain Mist quilt bats, which featured pictures, patterns, and quilting designs. "I assume that's where they came from," she said. "I can't remember for sure. I had no other patterns for quilting. These quilts had wonderful designs—wonderful stitching. I didn't make those from my head. I couldn't have made up patterns."

After those first two quilts she got busy raising three daughters, so it was years before she quilted for herself again. "Basically I didn't do it anymore. I didn't have the money," she recalled. For ten years Dortha worked at a sale barn. Two days a week she went to work at five in the morning and baked thirty-five pies to be sold during the day. She also helped with the rest of the cooking there. Sometimes she did alterations.

In 1941 Dortha became a member of a Selection Aid group that quilted to raise money for various causes. "They had started in World War I rolling bandages. Then they went into quilting quilts for people. People would pay. The price was one and a half cents per yard for thread. If we made ten dollars on a quilt, we'd done a lot of quilting. I kept up with that group." Through the years, the group was Dortha's social outlet. The women met in homes and served food. "It was basically part of my social life," she said. In the beginning, the group consisted entirely of farm women. Later, with changes in agriculture, some moved to town. She remained part of this group, which met every two weeks until it disbanded in the 1990s.

Through the years quilting was an art Dortha carried within her, but other than her years with the Selection Aid group, she had no time to sit down, cut pieces, and pick up a needle and thread. After retirement in the early 1980s, the Ashers moved to Knoxville, Tennessee, to care for their grandchildren while their daughter taught at the University of Tennessee. "Grandpa took care of the grandchildren. I got my quilting frame out and started quilting. I just had to have something to do."

After five years there, the Ashers followed their daughter and grandchildren to Pullman, Washington. "When we left Tennessee, I gave the fabrics and frame away. I assumed no one in Pullman would quilt." But she was immediately invited to join an advanced creative quilting group and began winning coveted prizes for her work. She learned Celtic quilting and shadow quilting.

Dortha's quilts are highly original and memorable. She makes old patterns contemporary. She can take an old pattern like a fruit basket and uniquely cut and combine colors to give the piece distinction. Some of her flowers have a three-dimensional quality. Sometimes she turns the patterns upside-down or cuts them in half. "I like to take a design and adapt it to my own way of thinking," she explained.

When she gets blocks made, she may arrange them on the bed. "Then I take a newspaper and lay it behind them," she explained. "I draw the pattern it will take to fill the spaces—to create what I want those spaces to have."

These days Dortha is often at home alone. Donald is in an assisted care facility and comes home for just a while each day. Dortha's fingers are stiffening from arthritis, but she continues the work she loves, often at her sewing machine. "I'm still making myself do it," she said. "I've always worked and hope to always work the rest of my life."

Considering lack of storage space for more quilts, she told her husband recently, "I'm going to have to quit making quilts."

"You can't do that," Donald told her. "You'd die."

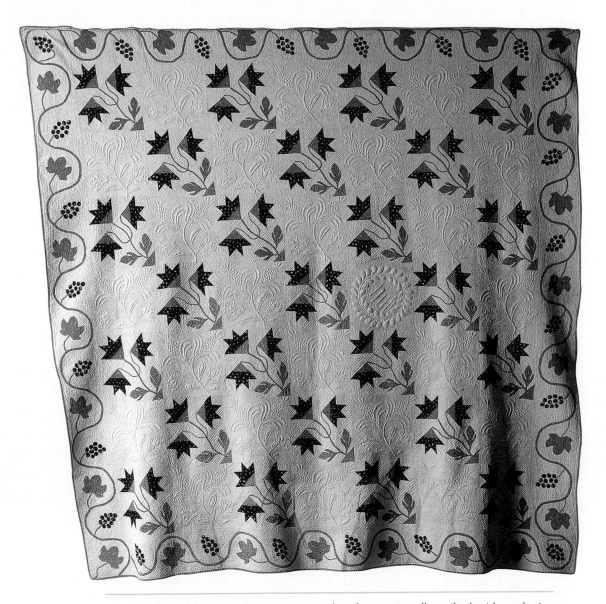

Pennsylvania tulip, 1849. This very personal quilt was proudly quilted with such tiny stitches that it does not lie straight. An interesting grape border contributes to this quilt's distinction. Written in India ink in a central block: "When I am dead and in my grave / And all my bones are rotten. / When this you see, remember me / Lest I should be forgotten. / To Sara Jane McClintock from her mother, Elizabeth McClintock, aged 69 years in 1849."
Grout Museum. Rod VanderWerf photo.

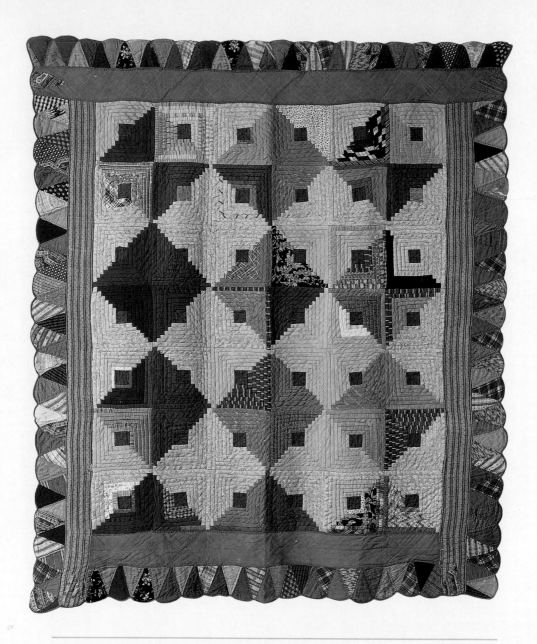

Log cabin (sunshine and shadow), 1800–1860. Susan Smith Graves, who lived from 1824 to 1905, created this quilt, which was saved by her daughter, Eva Graves Knapp. The logs were folded and hand-stitched to the foundation. The outer border acts as an impressive frame. Grout Museum. Rod VanderWerf photo.

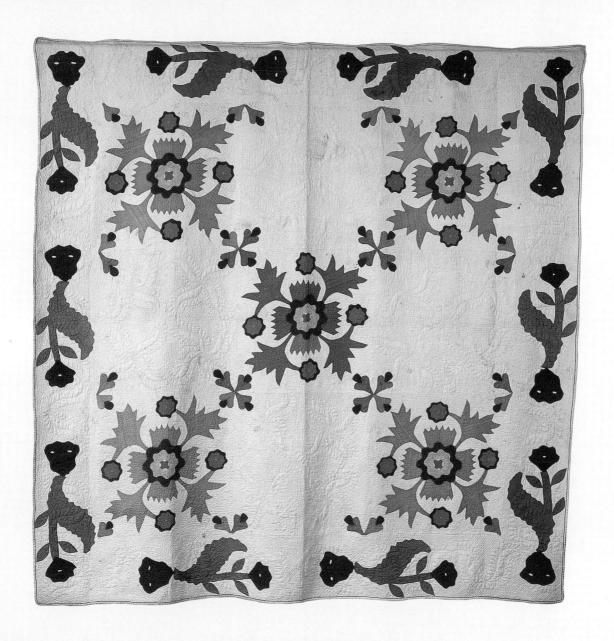

Cactus rose, 1840–1860. This appliquéd quilt has buttonhole stitches in some of the flowers' centers. Grout Museum. Rod VanderWerf photo.

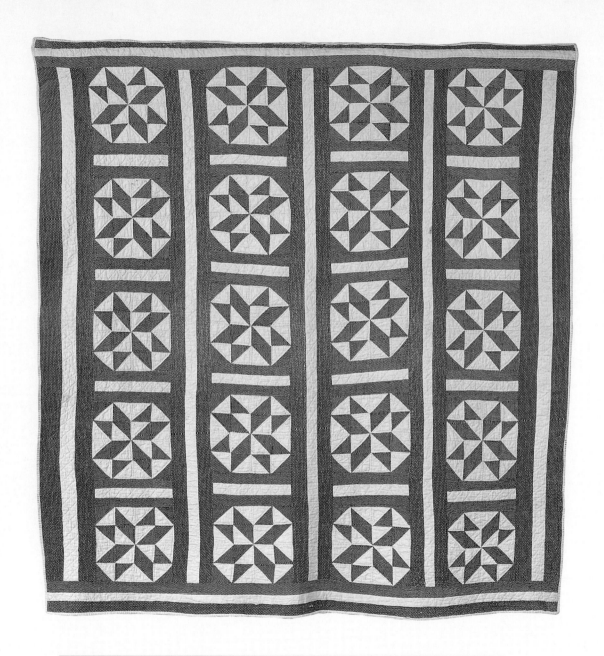

Barbara Fritchie star, 1850. An old card on the quilt says, "Made in 1850 by Mr. Mead's grandmother of Waterloo." The binding is machine-appliquéd and could have been added later. Grout Museum. Rod VanderWerf photo.

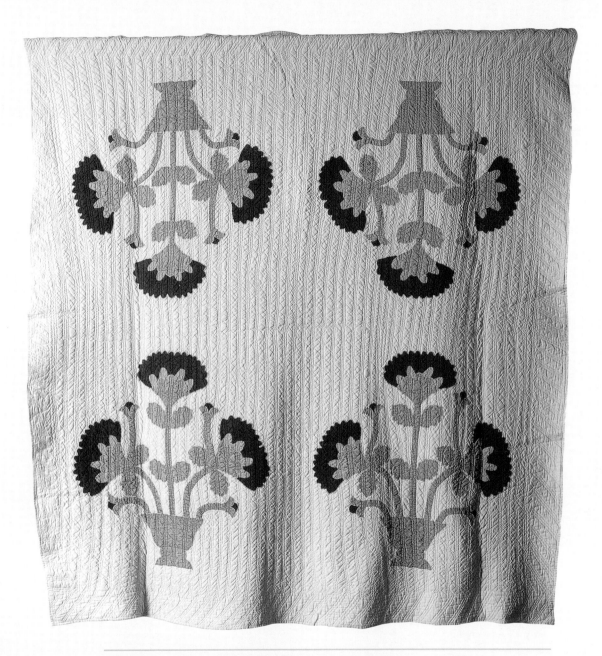

Flower pot, 1856. This appliquéd quilt of red coxcombs was created by Mrs. Samuel Rownd, Sr., a member of a prominent Cedar Falls pioneer family. Coxcomb was a popular pattern in the nineteenth century. Grout Museum. Rod VanderWerf photo.

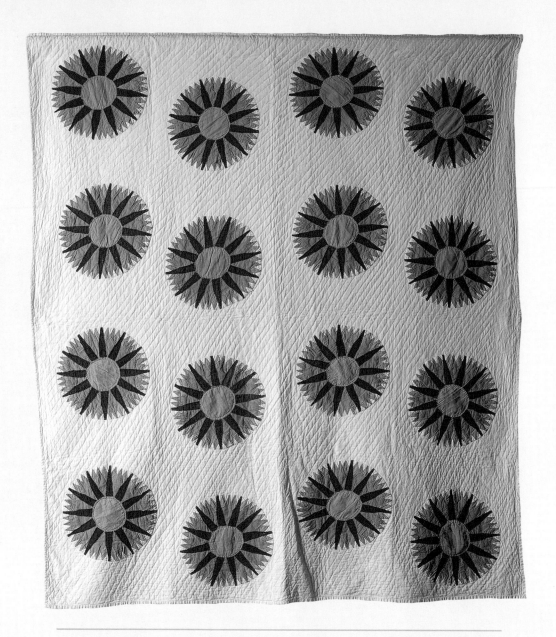

Sunburst or mariner's compass, 1850–1870. Old red and green blocks may have been pieced at an early date and later stitched onto the white backing and quilted. Often blocks were pieced and only later—sometimes a generation or more—worked into a quilt. Grout Museum. Rod VanderWerf photo.

Elsie Noble Ball and Mary Ball Jay

WRITING in a tiny brown spiral notebook, two sisters meticulously recorded notes about each of 135 quilts they devotedly stitched between 1935 and 1970. The yellowed pages, with blue lines, tell the story of the life work of Elsie Noble Ball—"Nobly"—and Mary Ball Jay, who day after day sat at quilting frames in southern Iowa creating quilts for others.

Carrie Short—February 1939
large quilt 3 yds by 2 1/2
thread used 1170 yds at 1 1/4¢—$14.62
small vine patch quilted in 1/2 squares

Miss Otto Estes
400 yds thread used—1 1/4¢ $5
cotton $.59
print for lining 7 3/4 $1
marking $1

Mrs. John Fluidt—Nov 1939
6 block square wedding ring
500 yds thread at 1 1/2¢ $7.50
 $1
 —————
 $8.50

In part, they quilted to have enough money to buy necessities for their small town life. But they were also continuing an art that was almost innate in the family. They had studied the blue and white quilt

their great-grandmother, Malura Calhoun Sens, made by candlelight around 1850. They had heard the story that she weeded onions to buy the material.

In 1964, while their hundred and first quilt was on the frame, Nobly penned notes about their quilting lineage, perhaps so relatives in the future could appreciate the history of their work. "Both grandmothers were taught the use of the needle early in life and continued its use into their eightieth years," she wrote. With obvious pride, she mentioned that their mother had worked in a tailor shop. "She made an overcoat for Grandfather Ball, as she had one of the first sewing machines in our immediate neighborhood. We also remember a very nice black broadcloth coat with velvet collar, cuffs, and pockets she made for Grandmother.

"Mother started her daughters using the needle as young girls, first hemming tea towels—or flour sacks, and making doll clothes," she continued. "We turned up our noses at the tea towel business, thinking if we could just make something worthwhile. A girlhood friend taught me to hemstitch a doll handkerchief. I'm going some now, I thought."

Daughters of Frank and Anna Isabel Calhoun Ball, the sisters were born on the farm their grandfather, Smith Ball, homesteaded in Round Prairie Township, Jefferson County. When the sisters' parents moved into Fairfield in 1912, Nobly lived with them and, in their later years, cared for them. Mary and her husband, Carl Jay, who gave up farming and eventually did odd jobs, built a house around the corner. After the sisters' parents died, Mary and Carl moved into the large family home with Nobly. The sisters set up the quilt frames that had been made for them in the manual training department at Fairfield High School.

A third sister, Edith Ball Bower, lived on her husband's family farm. Like many pioneering women, Edith quilted so that her home would be nicely furnished. In the winter when chores were fewer, she worked

at the quilt frame in the living room, making quilts for her family to use as mattress and bed covers, but quilting was never part of her livelihood.

Edith's daughter, Malura Alyn Bower Backsen, and her sister grew up on this farm fourteen miles east of Fairfield. Because this distance was too great to travel to school every day, the sisters stayed in town with their aunts during the week. "They always had a quilt in the dining room on a frame . . . two poles and posts on one end," Malura recalled. "They'd fasten a quilt to one side and then, as they quilted it, they'd roll it up until they got to the other end.

"My aunts were sewing all the time. They made quilts and sold them. They kept track of how much material and how much it cost to make a quilt. They sold to anybody in Fairfield." They were well known for a rolling stone quilt pattern that they used many times, one their mother had at the time of her marriage. The quilt took 483 yards of thread.

> Shoo Fly pattern for Mrs W.D. Stewart. A yellow print set with white muslin. 4 Blocks wide by 5 Blocks Long with a 2 strip border.

1 spool thread 325 yds @	$.35
Making quilt top and lining	$15.00
Quilted 219 yds @ 10¢	$21.90
Binding quilt	$3.00
	$40.25

> Started quilting June 13, 1969
> Finished quilting July 5, 1969
> Size 57 in wide by 68 in. long

This is for an "Antique Walnut" child's bed—belonging to some of Dr. Stewart's family

> Cotton left—$1.00
> Received $39.25 July 9, 1969

It was not unusual for the sisters to finish a quilt in two weeks. Mary was the faster worker of the two; she could stitch a yard of thread in ten minutes. The sisters were renowned for their small stitches. To do excellent quilting, they believed it was necessary to feel the needle coming through the cloth. They worked so hard that Mary wore a hole in the top of a keepsake silver thimble that her grandfather had given to her.

Quilting was the center of their lives, providing recreation and a backdrop for social interaction. "They'd talk about whatever was going on . . . the neighborhood gossip or whatever," remembered Malura. "If the phone rang, the others could take up the receiver and hear what was going on. Often, if someone was talking, others would chime in." Sometimes they listened to the radio, but even in later years television was not part of their routine.

The money earned from making and selling the quilts—sometimes only a few dollars per quilt—was an important part of their income. "They lived simply," remembered Malura. "They lived together. They were careful about what they spent. They didn't do much outside the home—just church socials. They went to the library to get books to read." Although Malura's two aunts lived prudently, their earnings didn't stretch into their old age. Malura and her husband, Howard, helped them out in their later years. "They depended on us," said Malura. "We were the only ones left to take care of them."

> Mrs. Archie Clow came with a baby quilt she wanted done.
> Started it Nov. 25, '69 = 110 yds thread
> quilted @ 10¢ = $11
> 1 spool thread (quilting) $.35
> Binding quilt $2.00
> ———
> $13.35
> Finished size 38 in by 56 in

A Baby Quilt for Mrs Russell Sheckler. A green and white cross stitch
white blocks set up with green strips. Started quilting Mar 12, 1970

110 yds thread quilted @ 10¢ =	$11.10
Marking quilt	$1.50
1 spool thread	$.36
	$12.96

Received check $13.00 Mar. 25, 1970

Away from the quilt frame, Nobly was a bookkeeper at Fairfield
State Bank, where she worked from 1918 to 1954. She worked with
numbers with the same care she worked with stitches. "She never
wanted to work at the window with people," said Malura. "She was
very precise." After retiring from the bank, she assisted in the offices
of the assessor, auditor, and treasurer at the Jefferson County Court-
house. Mary never worked away from the quilt frame, as she had
rheumatism. She kept her hands busy quilting and never complained.

Often the sisters quilted some of the hundreds of quilt tops created
by Lillian Walker of Fairfield, whose designs were known around the
state. Their favorite was an appliquéd one, bird lover's guide, inspired
by a *Sports Illustrated* cover in 1959. They also quilted the robin quilt, the
friends of the forest, and the old homestead. Malura remembered her
aunts' last quilt. "Nobly didn't feel well, and she was in a hurry to get
it finished. She was afraid she wouldn't get it done." Nobly died in
1971, Mary in 1975. "Aunt Mary didn't quilt after Aunt Nobly died,"
Malura recalled.

The pride and happiness of their work shows up in the notes Nobly
wrote in 1964: "There is joy about cutting and piecing the quilt blocks.
Good nerve medicine."

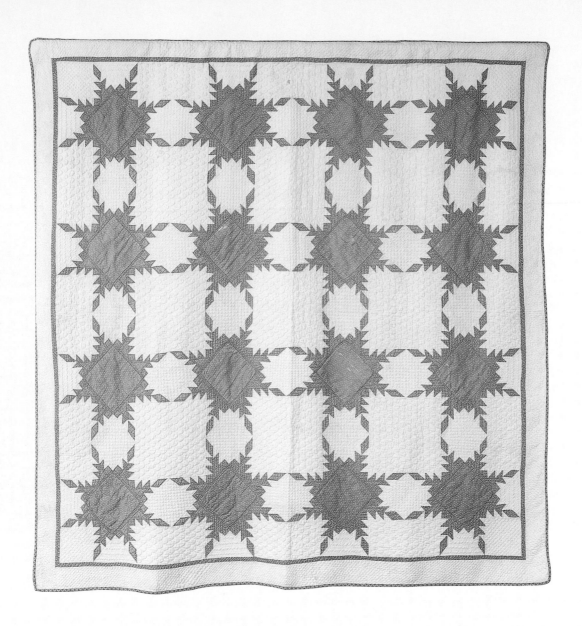

Feathered star, 1860–1890. The feathered star was a distinguished early pattern. In this quilt, the plain blocks have beautiful double-clamshell quilting. The borders are diagonal lines stitched one-quarter of an inch apart. The green blocks in each star's center were not quilted. Grout Museum. Rod VanderWerf photo.

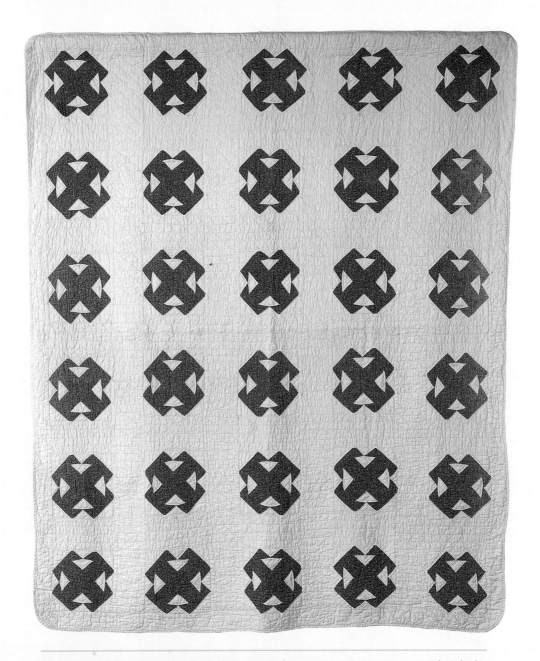

Capital "T," 1860–1890. Blue and white "T" quilts were sometimes associated with the Women's Christian Temperance Union, which lobbied against alcohol. Grout Museum. Rod VanderWerf photo.

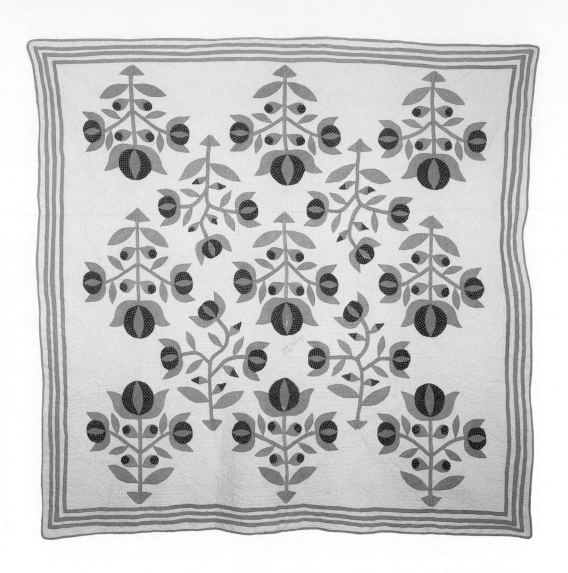

Love apple, 1875. Beautifully stitched, this quilt is signed "Sara Strong, 1875." A year on a particular quilt helps date its fabrics and subsequently those on other quilts. Author's collection. Addison Doty photo.

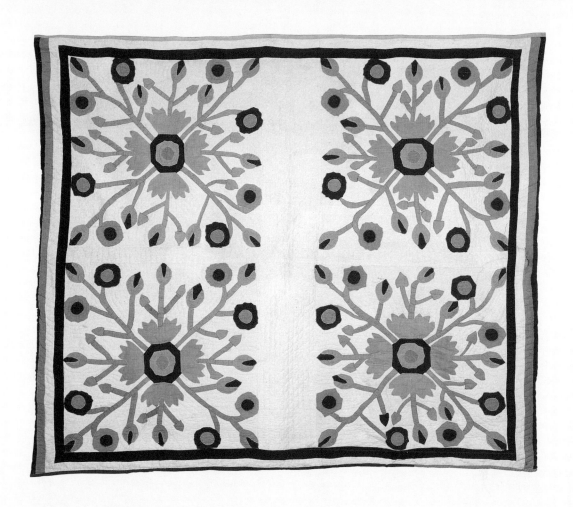

Rose appliqué, 1875–1880. The yellow-orange in this dramatic appliquéd quilt suggests it was made by a Pennsylvania Dutch quilter. Many Pennsylvania Dutch, seeking better farm-land, migrated to Iowa. The stitching around the appliqué is quite primitive. Author's collection. Addison Doty photo.

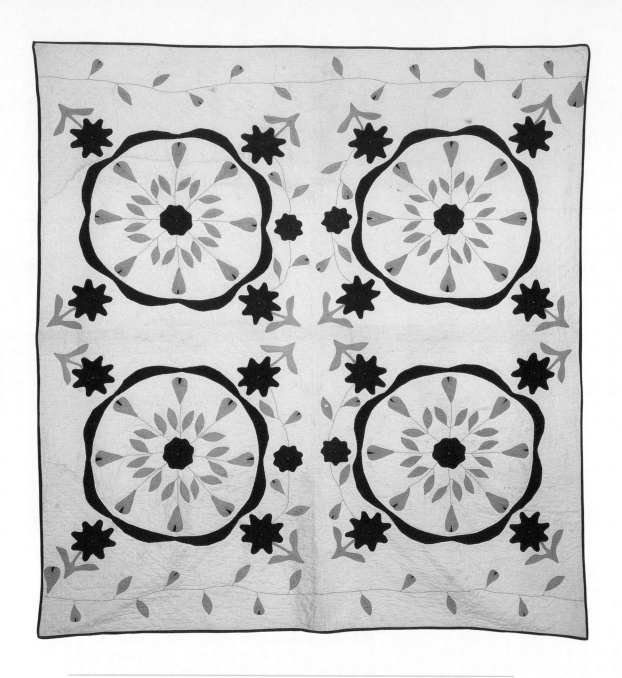

Individual geometric design, 1875–1880. This quilt was designed and appliquéd as if it were a giant palette. The flowers' stems are embroidered. Author's collection. Addison Doty photo.

Mary Premble Barton

PERHAPS it was feeling the beautiful stitches in the yellow and white appliquéd quilt her grandmother made for her as a child. Or maybe it was one of the intricate doll dresses made from leftover fragments she stitched while growing up on an orchard near Indianola. Or the remnants she used to make her first dress in sixth grade. Or it could have been the old beige comforter her mother made for her. Whatever the reason, throughout her life Mary Premble Barton has focused on old fabrics—their color, designs, care, and histories. She worked with them, learned about them like people learn about each other, and ultimately used them as palettes for her own quilt designs, culminating in an award-winning Iowa heritage quilt.

Through the years Mary, a quiet and carefully spoken woman, dutifully pasted her quilt lineage into a meticulously kept scrapbook. Her great-grandmother, Mary Stephens Crouse, who died in Panora in 1901, raised sheep, then washed, dyed, carded, spun, and wove the wool before making it into clothing for her children. After her mother died in 1968, Mary was going through a pile of things "from the home place" when she found a "make-do" mattress. Inside was a crude quilt made from Mary Crouse's homespuns. Mary used pieces from this simple quilt to repair a finer quilt of homespuns made by the same great-grandmother—a quilt Mary's mother had cherished until she died.

From her grandmother, Mary Alice Crouse Lisle, Mary inherited an old flying geese quilt in 1950. Mary used it on the beds of her four sons "until it could take no more." Another memorable quilt from her past is an album quilt that Mary Alice made with the names of her daugh-

ters and granddaughters embroidered on the blocks made from their respective worn-on-special-occasion cotton dresses. "The fabric on my block was from a dress I made in 1930 when I was in sixth grade," Mary remembered. She included in the scrapbook a tattered blue and white quilt that her mother used "for a kneeling pad while she worked in her garden."

Beginning with those early grade school sewing days, Mary also kept a scrapbook of fabrics used in her creations pinned next to the respective pattern covers. The fabrics remain as crisp and bright as the day she bought them. Peach: "High School Prom and Maypole Dance. Sash—green ribbon." Lavender: "Pi Phi Formal Dance in Simpson." Next to a Butterick pattern cover, she wrote, "I made this to wear at Simpson College. I tried to have something new each year." Just like the doll clothes, many of these clothes were made from leftover fabrics. "We would go to Des Moines and buy remnants in Younker's basement," she said. "I would even make my own coats."

After high school in Indianola and two years at Simpson College, Mary attended Iowa State University, where she majored in landscape architecture and met her husband, Tom, also a landscape major. Working on landscape architecture projects, she became a competent drafter, a talent that would later transfer to designing with fabric. During World War II, Mary drew navigational maps for the navy in Washington, D.C.

After the war, Tom worked in Des Moines, then in Michigan. They returned to Ames in 1955 when he took a teaching position at Iowa State University in landscape architecture. Always interested in older times, they would often take their four sons hiking along Iowa's rivers collecting rocks and looking for Indian artifacts and bones.

The dressmaking, the scrapbooks of fabrics, the interest in old objects, and the drafting and mapping experience were all a prelude to quiltmaking. It was not until after her mother's death in 1968, when Mary was going through mementos that included old quilts and fab-

rics, that her thoughts turned to quilting. At the time, Mary was active in the Faculty Women's Club. "I thought a talk on quilts would be a good subject for heritage days at Iowa State," she recalled. "I did the best I could with what knowledge was available. I gave a talk on my family quilts."

There was so much interest that she organized a quilting bee for the general assembly of the club. She talked about the quilts various Ames families had tucked away in their trunks and closets. "Then people started asking me questions about their quilts. I started researching."

She also started buying old quilts and boxes of old fabrics at auctions. She turned a bedroom porch into a quilt room and started sorting fabrics by color. She bought early women's magazines and read them for knowledge about the canning and cooking stains from earlier times. (Of special interest to her was information on strawberry stains.)

Then, using creativity, pencil, scissors, and interesting fabric, Mary started designing and piecing her own quilt tops. "I saved the family's history and everyone else's through fabric," she said. An early effort was a quilt top for her son Arthur. "It wasn't successful," Mary remembered. "It didn't have strong contrast between light and dark. It was done by hand, but I didn't do the quilting. I never did the quilting on my own pieces."

A seven-year effort to transcribe into cloth her heritage, her memories, and her love for rural Iowa started when her mother died. "I used to take a block at a time when I went to see my dad. I'd work on the block down there. One year I was so busy with the Faculty Women's Club that I hardly picked it up at all. I'd work on it anytime I had a few minutes free. I thought a lot at night about what the next row would be."

The resulting quilt illustrates the story of the pioneer migration to Iowa. Each woman has a quilt block. The men carry the edges, with the hay forks, grain shovels, hoes, and axes they needed to build houses

and start farming. There is a grand eagle in the center, reminiscent of the eagles in quilts of the 1840s when Iowa was settled. The eagle was cut from drapery fabric in *broderie perse* style. For roofs on the houses, Mary used fabric from old aprons and housedresses from the last two centuries. She dissected an old and worn quilt, using the fabric mostly in a map of the eastern United States that depicts the migration routes. Fabric samples from stores were also worked into the quilt. Having difficulty finding enough green colors, she eventually bought some from the Vermont Country Store.

One of the swatches stitched into the quilt is a memorial to Mary's brother, Bill, who was shot down on his first World War II mission in the mountains northwest of Tokyo. "They finally found his grave," Mary recalled. "They figured it was his because of the color of his hair and the size of the uniform."

Mary created the quilt's design, but the quilting was done by women at St. Petri Lutheran Church in Story City. "It took patience to piece. It was creating a design that was the most important part. When I hung it from a beam in the living room after the quilting was done, I knew it was special. I entered it in the National Bicentennial Quilt Contest. I got a ribbon."

In the other "oh, fifteen or twenty" quilts she made, she would repeat the design in a quilt that she had seen and liked. She bought a windflower quilt top at auction in Massachusetts and recreated it in other fabrics. Sometimes she would mix old fabrics with new. In a blue and yellow tree everlasting, she used pre-1930 indigo blues, but the golden yellow is new. The quilt, pieced in the English way and quilted by Sara Miller of Kalona, is now at the State Historical Society of Iowa.

About a sunshine memory lap quilt made in 1982, Mary wrote: "I started piecing this after seeing a magazine cover. I was able to finish it after seeing the whole quilt pictured in a quilt calendar. Part of the fabric was from a sunshine costume that I wore in a program given by

Sunday School primary classes. The red was someone's old curtain. There is both old and new green. Pieced in the English way."

During Desert Storm, she finished a red, white, and blue flaglike quilt that incorporated four bandanas. In 1976, she started a quilt of horse heads, her own design, but did not finish it until 1992. "This quilt was for Art's kids to use when they were sick." But for Mary the quilt was in reality a recreation of a childhood memory. "We had ponies in the summer, and in the winter they went to live in the country where they could be used by children going to school," she said.

Of a handsome red and green colonial basket, she wrote, "I purchased the red 'Grandma print' fabric in 1965. I used a matching gold print in the heritage quilt. The fruit fabric is from a dress purchased at a thrift shop in the 1970s. I cut out the sections of fruit and leaves and basted them on ready for machine-appliqué."

Mary raised her family in an older home that she and her husband carefully restored on a wooded lot on Squaw Creek in Ames. After Tom died in the 1980s, she moved to a more contemporary one-story house. Ironically, the house is almost empty of quilts, except for a blue and white one she keeps on her bed. It's the quilt from her grandmother. "It's the old quilt my children used. I put it through the washing machine. I took it apart, saved the good parts, redid it, and had it quilted."

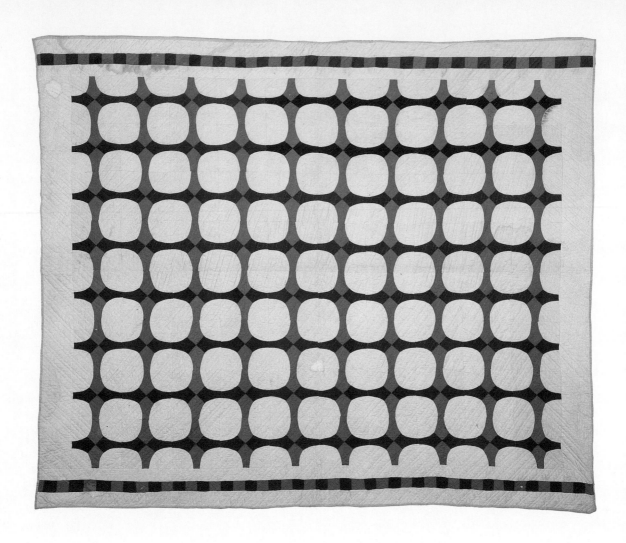

Snowball, 1870. This quilt incorporates plain red and olive green fabrics of the time. The left corner was probably purposefully finished with turquoise fabric, making the design "imperfect." The decidedly different quilting stitches throughout suggest it might have been the project of a quilting bee. Some pencil lines still show. Author's collection. Addison Doty photo.

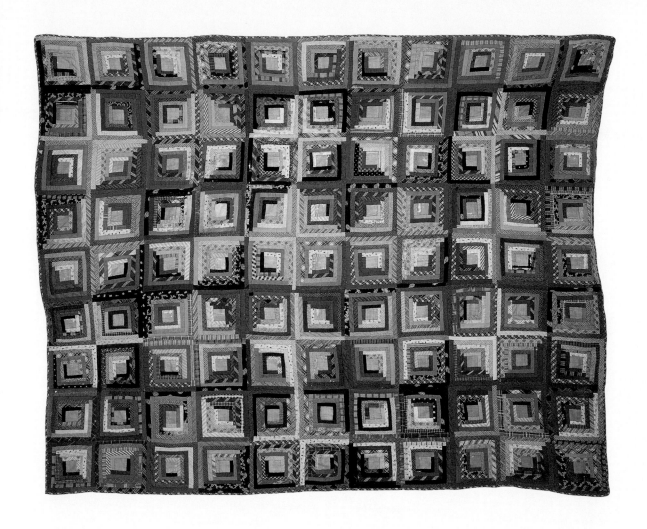

Log cabin, 1875–1880. The log cabin, symbol of the American frontier, was a popular design during the nineteenth century; "logs" were layered on the quilt backing. This log cabin is unique in that blue fabric is used for the heart—hearth—of the home rather than the usual red. Thin wool fabrics were used. Author's collection. Addison Doty photo.

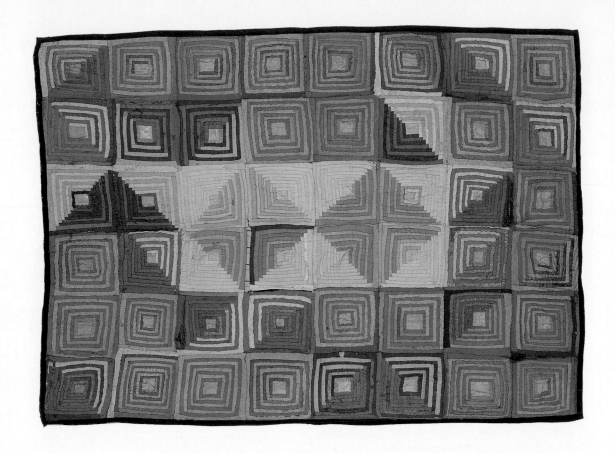

Log cabin, 1875–1880. This delicate wool child's quilt has a blue center square like that in the quilt on page 27. Author's collection. Addison Doty photo.

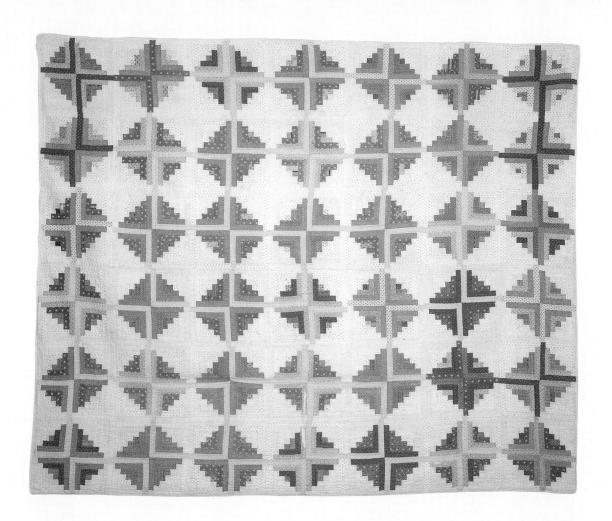

Log cabin, 1875–1880. This light and dark variation of the log cabin was made with calicos.
Author's collection. Addison Doty photo.

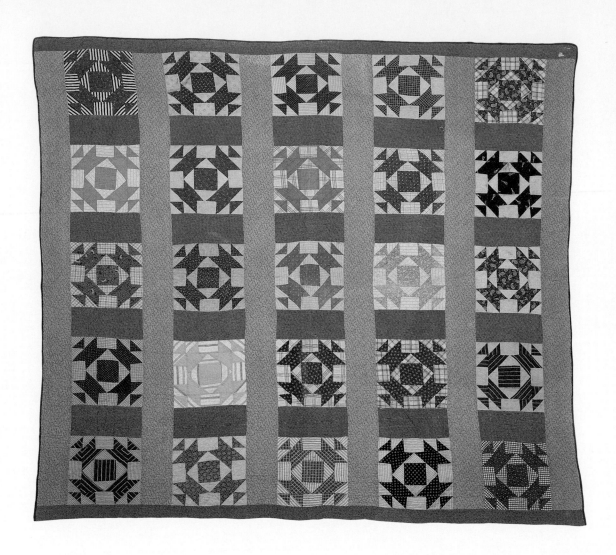

Broken dishes, 1860–1875. Robin's red breast fabrics, like the ones in this quilt, often date to the 1860s when they were popular. Author's collection. Addison Doty photo.

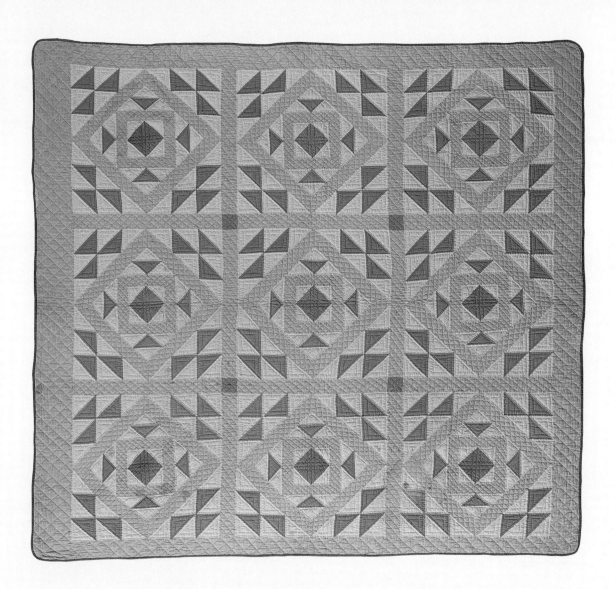

Cleveland's choice, 1875–1880. The maker obviously planned this design carefully, coordinating two hues of brown. The pattern was a popular one during its time. Author's collection. Rod VanderWerf photo.

Frances Brewton

FRANCES BREWTON recalled that around 1912, during recess in a two-room, segregated grade school in Collinsville, Illinois, she looked across the street and saw a "French lady" on her porch, crocheting. "Her hands were flying, and I wanted to see what she was doing." Curious and determined, she asked her teacher if she could walk over to the woman's house and watch her crochet. "She told me I'd have to get a note from my mother, which I did. I'd go over every recess—morning and afternoon—and watch her. I'd use cord string for crocheting because we couldn't go into stores to buy stuff like other kids did." In fact, Frances, who calls herself a Negro ("I'm not African American"), walked two and a half miles to an uncle's store to get the cord so she could make simple items like dish cloths. By the age of seven, she was crocheting. Quilting followed.

Frances pulled a pouch from a shelf in her neat one-bedroom apartment in downtown Des Moines. Inside the pouch was a collection of crochet needles, gifts from friends through the years. Tucked carefully into a fold were two yellowed ivory needles, keepsakes from the French woman's husband, who carved them especially for Frances out of "wasted" ivory.

Frances' mother was an accomplished seamstress. Often she would go to the second-hand store, buy cast-off designer clothing, and re-make it for her eight children. With admiration, Frances watched her mother sew, but she did not want to sew clothes.

"She tried to teach me to sew. I didn't want to sew. I wanted to do like Grandma," she remembered. Her mother's mother, a Canadian

33

Indian, had learned quilting from *her* mother, Frances' great-grandmother, who had come to Canada from England and, according to the family stories, had taught quilting to women who were holding their homemade blankets together by simply tying them.

Frances' grandmother often made quilts for the children of new families in the neighborhood. She would work with six or eight women; four would piece and four would quilt. "She let me quilt on a big quilt beside her," Frances recalled. "If I made a big stitch, she'd look at me and say, 'Na, na.' I'd say, 'What do you mean?' She'd say, 'Pull it out. It's too big.' I had to make little ones like her. She'd say, 'If you don't get but two stitches on there, make them the same size.'"

Soon, Frances' interest became a passion. "Instead of going out and playing, I'd stay in and quilt. Mother said, 'You're wasting your time.' I said, 'No, I love to do this.'" Soon Frances was quilting on her own, using leftover scraps from her mother's sewing. "I made the variable nine-patch because I hadn't learned to cut fancy pieces yet," she said. "I learned that in high school."

While still a teenager, she made the star quilt that she later gave her grandson. "I had different pieces labeled as to what they were—pajamas, dresses. My mother even made men's chambray shirts." Along the way, she taught herself to create any quilt design she wished. "I'd look at someone else's quilt, keep it in my mind, and draw it on my own," she recollected.

Frances was born in 1905 in Collinsville, where her father, half Irish and half Native American (Black Hawk), worked for the railroad. Her mother was part Indian and part "Negro." Soon after she was born, her father's work on the railroad took the family to Omaha, then to Estherville. "Every time we turned around, we were packing up to move," Frances remembered. She recalled the adversities they encountered when they first moved to Estherville. "There was prejudice," she said. "When Dad came, they rented him a place. He looked

white. When the kids came, they took the keys and wouldn't rent to us. We slept in the depot a few nights. Then the railroad master asked if we'd mind living in the Mexican village. The railroad hired Mexicans to fix the tracks. There was a village of boxcars. My dad said he didn't mind. We lived in a boxcar for three years."

Her memories of that time—actually living in two boxcars—are vivid enough to bring a smile to her face. The boxcars had a kitchen, dining room, living room, and four bedrooms. "My dad dug underneath and made a storage basement where we played in the winter. There was an oval horse trough we took baths in."

When World War I started, the family moved to Davenport, where Frances' father worked in the Davenport Arsenal. After the war, they packed up again and headed to Cedar Rapids, where Frances attended Washington High School and combated some vicious prejudice. She told her English teacher that she wanted to be a secretary. "I don't think you need to take business," the teacher told her. "People of your color won't get a job as a secretary." Frances, who admitted she has always had a strong sense of self, retorted, "You're here to teach, not to downgrade." That wasn't the worst of it. "One day she called me a nigger. I hit her with the geography book. She got fired after I hit her. Mr. Turpien, the principal, didn't believe in mistreating children in school. He said, 'We're here to teach, not to downgrade.'" Frances took the business course, which gave her tools to help her to support herself throughout her life.

After high school, Frances helped her mother, who was renowned for her barbecue sauce, with a catering business in Cedar Rapids. In 1924, she married Cecil Brewton, whom she met in Iowa City while he was a medical student at the University of Iowa. After two years of school, his funds ran out, and he became a medical technician instead. Frances and Cecil spent most of their lives together working hard and raising two sons on Laurel Street in Des Moines. In 1937, she became a

Democratic party secretary. Friends she met in this position helped her obtain a subsequent job as a secretary in the Iowa Department of Rehabilitation, where she worked until she retired in 1972.

During her working years, Frances took her crocheting to the office to work on during breaks. Evenings and weekends she quilted, sometimes with Cecil's help. "He quilted, but not as good as me," Frances said with a slightly smug smile. "He'd do the marking." After retiring, she continued to earn money quilting tops for others. Cecil died in 1988 before he could know that Frances would go to Washington, D.C., and quilt on the Mall as part of the Thirtieth Anniversary Festival of American Folk Life at the Smithsonian Institution Center for Folk Life, Progress, and Cultural Studies.

What is it about quilting that has mesmerized Frances through the years? "It gives me a feeling I've accomplished something someone else hasn't. The more I do, the better I like it."

Missouri puzzle, 1875–1880. This is a complex and dramatic overall design. This particular quilt demonstrates how simple blue and white calicos from old clothes were transformed into works of enduring beauty. Author's collection. Addison Doty photo.

Nine patch variation, 1875–1880. The old polka-dotted blue calico dress fabric used in this simple but elegant quilt was a popular fabric at the time. Author's collection. Addison Doty photo.

Hovering hawks, 1875–1880. The red (which has now faded), white, and blue used in this quilt suggest that it was made as a patriotic quilt to celebrate the anniversary of the signing of the Declaration of Independence. Author's collection. Rod VanderWerf photo.

Streak of lightning, 1875–1880. Pink and blue calicos were worked together to make this crib quilt dramatic. Author's collection. Rod VanderWerf photo.

Prairie lily, 1875–1890. Variations of this cherished pattern traveled across the country with the early settlers and were named accordingly: Carolina lily, Ohio lily, wood lily. Author's collection. Addison Doty photo.

Barbara Chupp and Salina Bontrager

❋ SALINA BONTRAGER, the youngest of nine children growing up on a drought-stricken farm in Oklahoma, was two years old when her father, overwhelmed by Depression debts, abandoned his family. The Amish family was despairingly poor, but Salina's mother, Barbara Chupp, gardened, baked cornbread, sewed for others, and hatched chicks so that there was enough to eat. "She never ran out of anything," Salina recalled. "When she was down to her last jar, she saved it."

Salina, her wavy gray hair pulled back under a white cap, never sits and maybe never has. She stood in her comfortable, efficient, modern Iowa kitchen in a large white farmhouse, hands on her hips, thinking ahead to the next task on her day's agenda while she reflected on those tough years. "We scratched for everything we had. Us children, as soon as we could, helped other farmers in the summer." Salina and her brothers and sisters helped neighbors can food, washed their windows, cleaned their houses, and butchered their chickens.

Their house was primitive. There was no running water. The floors were roughly painted boards. There was no electricity. Laundry was done on a scrub board. They walked to the store to make a phone call.

Her mother, Salina recalled, did not hand down her sewing talents easily. "She was so particular that you do everything just right. She was not good as a teacher. She'd rather do it herself." Barbara was born in 1895 in Haven, Kansas, the oldest of fourteen children. She milked cows and cooked, and even as a child she did most of the sewing for her family.

She married Menno Chupp, a farmer, and in 1928 they moved to what they thought would be better farmland in Oklahoma. It was here that Barbara started piecing quilts for other people in order to earn money so the family could eat. After her husband left, the little money earned from quilting became a necessity. "They found out about her and would bring her a box of scraps they had. Later they would buy material and bring it to her," Salina related.

Barbara's frugality worked its way into her quiltmaking. Her signature was taking the tiniest of scraps and almost knitting them into a quilt. "Other people would have thrown away pieces she used," Salina recalled. "She never believed in throwing anything away." She pointed to the brightly colored yet delicate double-wedding-ring quilt that her mother had pieced—one of her last works—with scraps as tiny as glass in an ancient mosaic. Salina had quilted it.

Salina's life eased somewhat after she met her husband, Joe, while visiting a great-aunt in western Oklahoma. "We'd go and visit an aunt, and we got to know each other," she remembered. They were married in 1955 and farmed in Oklahoma for a few years. In 1964, they moved to Iowa, where his parents lived. Salina and her husband bought a dairy farm west of Kalona, an Amish settlement, and named it Joetown Dairy, in honor of her husband as well as to commemorate tiny nearby Joetown.

"Mother said she wanted to come with us," Salina recollected. They built a separate house, a tiny, tidy frame house, for Barbara, who was sixty-eight at the time of the move. She immediately started piecing quilts for people in the area in order to earn money. "I'd take food over," Salina remembered. "She wouldn't take time to cook, she was so busy piecing."

While Salina and her family lived a modern rural life with electricity, telephones, and automobiles, Barbara lived her life as spartanly as she always had. "Mother was always Old Order," Salina said. Every

winter she put her chores aside, set up a table, and devoted two weeks to quilting with her mother. Salina cut the scraps into pieces, something her mother did not like to do. "You had to iron and then cut each individual piece, and that took time. She never wanted me to sew. She didn't think anyone else could do it. Up until she was ninety, she did a good job. After that she'd get the wrong patterns together and they wouldn't fit. That was frustrating."

Salina picked up a wad of pieced squares. "Here are things she did. She was eighty-eight. She was hardly able. She finally had to give up, and it was hard for her to give up—hard for her when she couldn't sew. I finally had to say, 'Mom, you can't do it anymore.' When she couldn't do it, she went down physically."

Salina's husband, Joe, suffered from a heart condition for many years. At the age of forty-nine, in 1984, he died. Barbara's decline was compounded, and Salina's farming and family responsibilities were onerous. "The hardest part was being left alone with that many little boys," she recollected. "I thought, when my husband died, 'I can't do it alone.'" She did, "by the grace of God." Merle and Mary had married and left. At home were Karen, twenty-three; Marlin, eighteen; Gary, fifteen; LaVon, eleven; and twins Wayne and Wanda, nine.

Today Marlin and Gary do the farming, although Salina's role is still a major one. "I owned everything until 2001," she said. "They worked for me, and I paid them a wage. Before 2001, I gave them spending money for clothes, a car." As if raising children and running a farm alone weren't enough, Salina also cooked for the Kalona Historical Society, something she has done since 1970. When the society schedules tours, she is "head cook" for the group.

Today a table and a bed—"We don't use the bed now so I put the noodles on it"—are piled high with hand-rolled egg noodles, a recipe seemingly effortlessly made with seventeen dozen eggs—"I'll take the whites and freeze them in containers for angel food cakes." This week

busloads of tourists are going to visit historic Kalona. She is responsible for serving them an Amish dinner—roast beef, mashed potatoes, noodles, green beans, coleslaw, and tapioca pudding.

Salina continues to quilt in the winter for relaxation. While her mother specialized in creating colorful, complex quilts out of scraps, Salina, perhaps remembering the hours spent cutting pieces for her mother, often makes simple plain-top quilts. "I just gave a plain-top quilt to my son Marlin," she said. "Each child has a plain-top quilt in white or off-white. Mother didn't make plain-top quilts."

Although Salina, wearing a conservative cape dress, may look as if she is a part of earlier days, she is successful as a mother and modern-day businesswoman. She credits her mother with encouraging this achievement. "When we were going through hard times, I was able to cope."

Chimney sweep, 1875–1890. When the squares were signed, these were called album quilts. This quilt has a backing created with wide strips of different fabrics—almost a quilt in itself. Author's collection. Addison Doty photo.

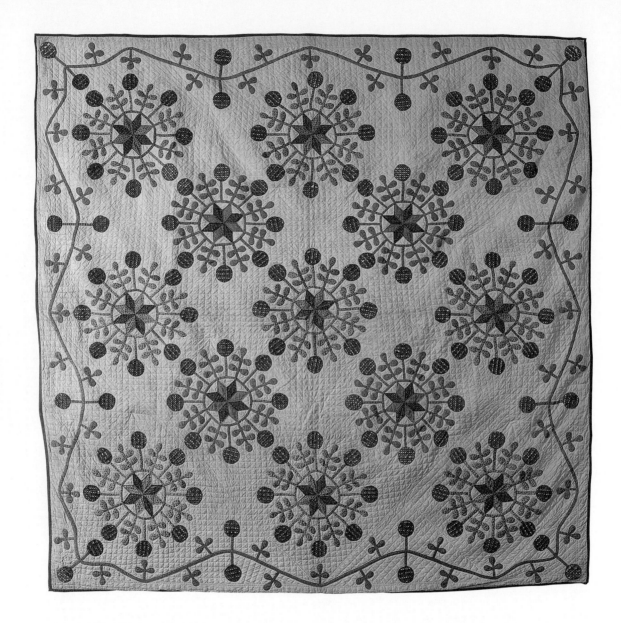

Unidentified design, 1875–1900. The maker of this quilt, who lived in southern Iowa, worked out an exceedingly complex quilt design incorporating many different shapes. This was a challenging quilt to cut, piece, and quilt; it is a lasting piece of art. Author's collection. Rod VanderWerf photo.

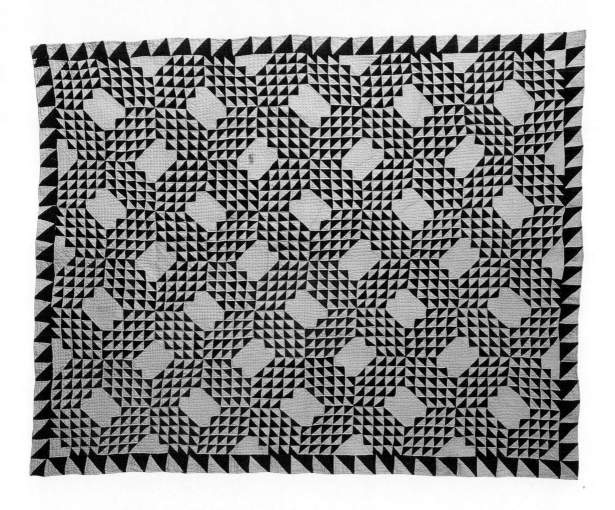

Ocean waves, 1875–1890. A sawtooth border frames this stunning red and white quilt created from many tiny triangles. Author's collection. Rod VanderWerf photo.

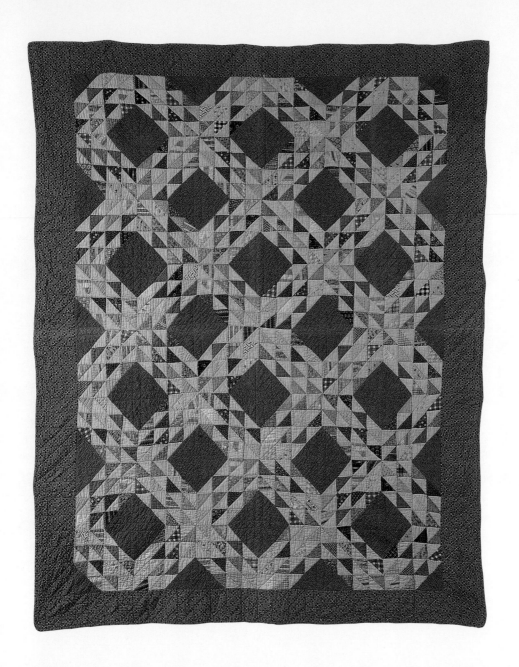

Ocean waves, 1875–1900. This is a multicolored ocean waves quilt, giving it an entirely different look from that of a two-color quilt. Collection of Leanna Reidy. Rod VanderWerf photo.

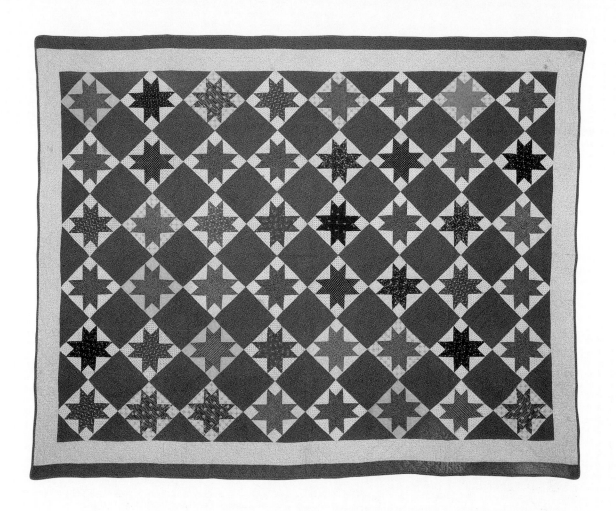

Variable star, 1875–1900. The eight-pointed star has always been a popular pattern, taking on different looks with different fabrics. Author's collection. Addison Doty photo.

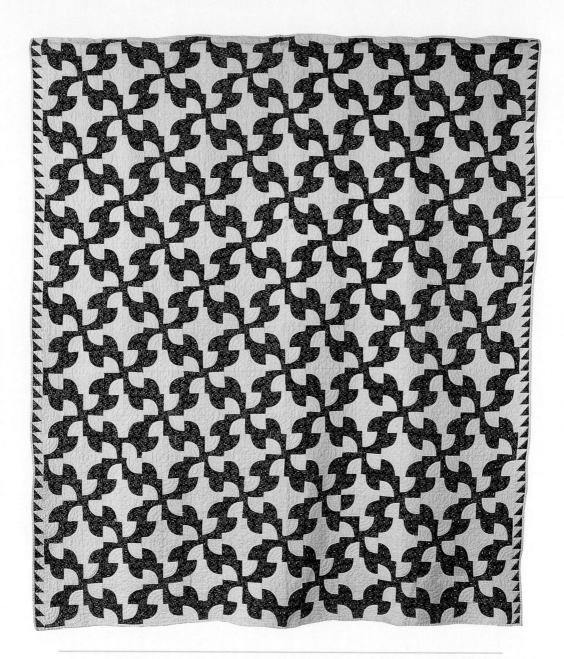

Robbing Peter to pay Paul, 1875–1900. A two-color quilt, dark brown and white, was made even more striking with a sawtooth border. This pattern was also called drunkard's path.

Grout Museum. Rod VanderWerf photo.

Robert and Sadie Echelberger

ROBERT ECHELBERGER, seventy-two, tall, thin, and dead serious, stood between his fully gadgeted sewing machine and a colorful hill of miscellaneous bright cotton fabrics in the sun-cheered basement of the small house on the south edge of Mason City. Robert was as absorbed in his quilting as a physicist might be with a tricky problem. Red-haired Sadie, sixty-eight, his genial and pretty second wife, walked down the stairs into the room and, in her quiet way, just by being there, broke his weighty concentration on stitches.

Robert sat down and, with a not-so-subtle twinkle in his eyes, listened while Sadie, also a quilter, explained how it works when husband and wife quilt together. "We tend to get in each other's way when we're both working on a project, and one has to give," she explained forthrightly. Robert smirked in agreement.

Robert taught in public schools for thirty-five years. Twenty-five of those years, he taught woodworking at Roosevelt Middle School in Mason City. He enjoyed teaching and the never-throw-anything-away resourcefulness of taking raw materials—wood, metal, plastic, and ceramics—and converting them into usable products.

A widower when he retired, Robert no longer had access to woodworking machines. At the same time, the yearning to create with different materials did not diminish. Years before, he had been intrigued watching his first wife's mother cross-stitch. To him, cross-stitching contained the same elements as woodworking: transforming materials—in this case thread and fabric—into something attractive. "That's

how I got interested. I enjoyed hunting and fishing, and I wanted to cross-stitch fish and game. I got myself cloth, floss, and a pattern."

That was 1990. He was as captivated with his new interest as a child finding a novel toy under the Christmas tree. He moved on to counter cross-stitching, over waste canvas, then on to cotton to make his stitches finer. "I got patterns for different wild animals. I made squares, and my daughter put them together. Nothing was symmetrical—none of the squares—and it was a challenge for her," he remembered. He was fortunate to be getting this assistance from one of Iowa's most knowledgeable quilters. His daughter, Jennifer Bernard of Webster City, is a prize-winning quilter and a leader with the Iowa Quilters Guild.

Meanwhile, Robert met Sadie at Stepping Forward, a social group for widows and widowers in Mason City. Robert, who has an appealing shyness, timidly stalled six months before inviting Sadie on a date. Their marriage bonded two hard-working people who had endured the rough times and sorrows that come as life unfolds. Sadie had grown up, one of thirteen children, on a rented farm in Castlewood, South Dakota. There was no running water, no plumbing, and no electricity. Sometimes dinnertime came, and there was nothing to put on the table. "We usually had something—bread if nothing else. Fresh bread in the house. It was tough, but we survived. We had to do chores. I did what all the boys did—milking cows by the time I was five." She sewed clothes for herself and her siblings.

Before she finished high school, she married William Christeson. "I wanted to get away from home," she said frankly. The couple followed construction projects across the upper Midwest and eventually settled in Mason City, where Sadie has lived for forty years. She and William, who leased a service station, raised three children. He was hurt in an industrial accident and died young. "You do what you have to do," Robert interjected. "Life is not always a bed of roses, but you keep going." Robert carries his own bundle of grief. His wife, Shirley, was

killed by a drunk driver. He was left to raise Tom and Russell, the youngest of six children.

With Robert and Sadie's marriage in 1993, the work of Jennifer, who had helped her father put together two quilts, shifted to Sadie. "I had to do something with the squares," he said. "You can only hang so many on the wall." "My mother and I put quilts together when I was a kid. I had to start helping him," said Sadie, who has some arthritis. "In self-defense, I had to ask him to put them together himself. I spent a lot of time helping him."

He eventually started putting the squares together, then quilting. Sadie was still doing the machine work—the binding. "You've got to learn to do the machine," she urged Robert. She looked at him proudly. "It's just the last few months that he put his own borders on them."

Together they have worked on a beautiful Hartford star quilt. He pieced it, and they both quilted it. "He'd quilt on one end. I'd quilt on the other," Sadie mused. "Sometimes we'd talk. Sometimes we were quiet. I'm his worst critic. I make him tear stuff apart. He used to get mad at me, but now he realizes it's for his advantage." Does he get upset? "I just mumble a lot," he answered.

Robert has recently perfected the art of ribbon embroidery. "I started doing ribbon embroidery," Sadie noted. "He wanted me to do something. I told him he'd have to learn to do it." He's proud of his quilts. "I get the same satisfaction as if I were making a bedroom set or a coffee table. It looks better the longer you have it. You forget the mistakes you made."

Each partner has a signature specialty. Robert does detail work, often doing paper piecing, which allows for the tiniest of designs. He also has an eye for fabrics and how they work into designs. He likes bold colors and is not afraid to use them. "She tells me I can't buy any more material," Robert complained humorously. "You end up with material in boxes, dressers, and every which place," Sadie answered back.

When it comes to the actual quilting stitches, their techniques are dissimilar. "He does more of the punch type," said Sadie. "I do more running." She takes her meticulous stitches as far as they will go into the world of art. She showed off a beige-on-beige quilt, an art piece, with a raised design and twelve panels of quilling. "He hasn't touched a needle to that quilting," she said in jest, but proudly.

Both Robert and Sadie have won prizes at the North Iowa Fair and the Iowa Quilters Guild. Robert's quilts have been on display at the Grout Museum in Waterloo in an exhibit that featured quilts by men. Ask him what other men think about his pursuit. "They haven't said anything." He kept right on stitching.

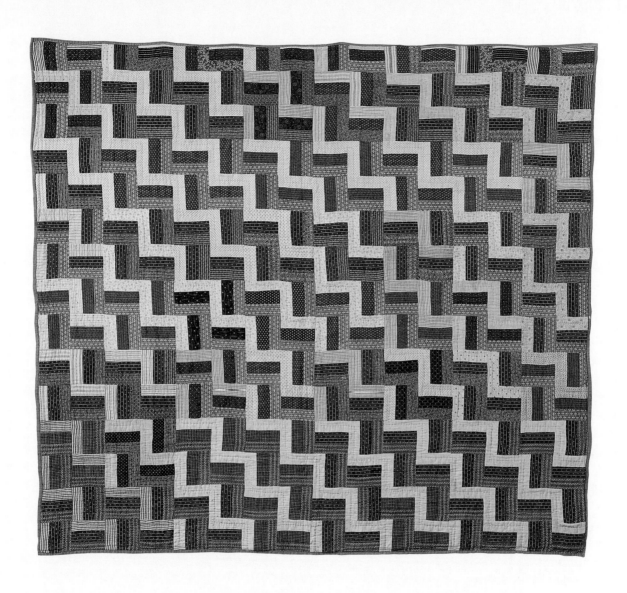

Rail fence, 1875–1900. The black fabric in this simple but dramatic quilt was probably taken from a woman's mourning dress. The stitching in this quilt is very primitive, possibly the work of a child. Author's collection. Rod VanderWerf photo.

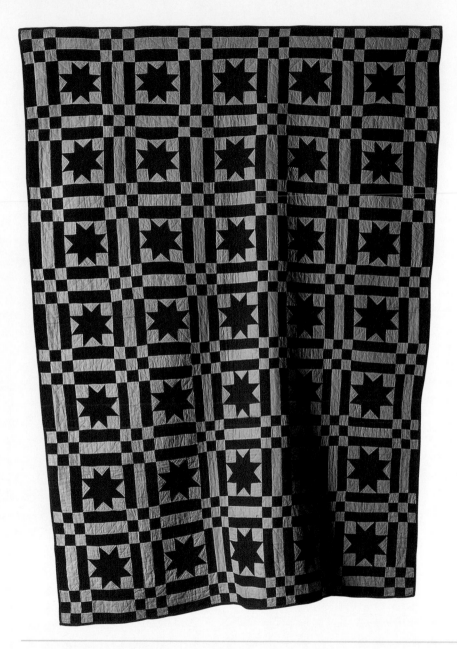

Mother's fancy star, 1875–1900. This small, striking quilt has a patriotic feel to it. Many quilts made around 1876, the anniversary of independence, were patriotic. Grout Museum. Rod VanderWerf photo.

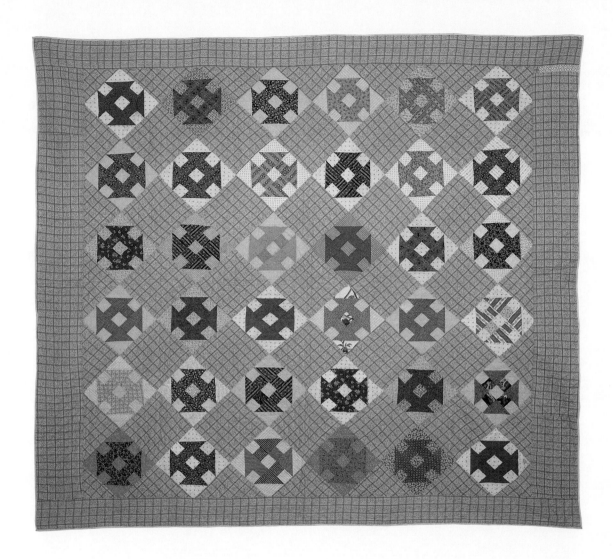

Monkey wrench, 1875–1900. Quilts were often named for objects that were part of rural everyday life. A potpourri of fabrics typical of the time were incorporated into this quilt.
Author's collection. Addison Doty photo.

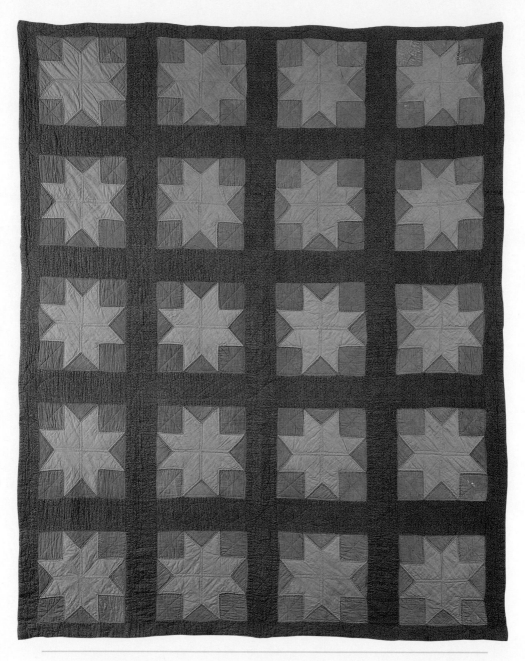

Star, 1875–1900. A creative use of colors—pink, orange, and blue-green—makes this quilt look contemporary. Collection of Leanna Reidy. Rod VanderWerf photo.

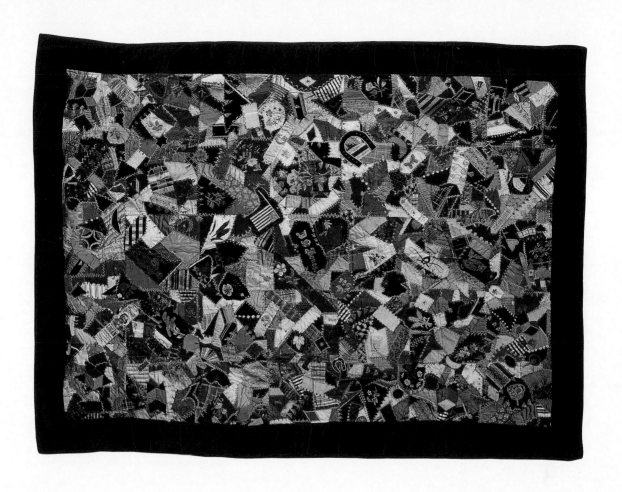

Crazy quilt, 1884. Ribbons of Iowa political candidates, a Happy New Year's ribbon, and a ribbon touting Dubuque are some of the pieces of this amazing puzzlelike quilt that tells a bit of the history of its time. Grout Museum. Rod VanderWerf photo.

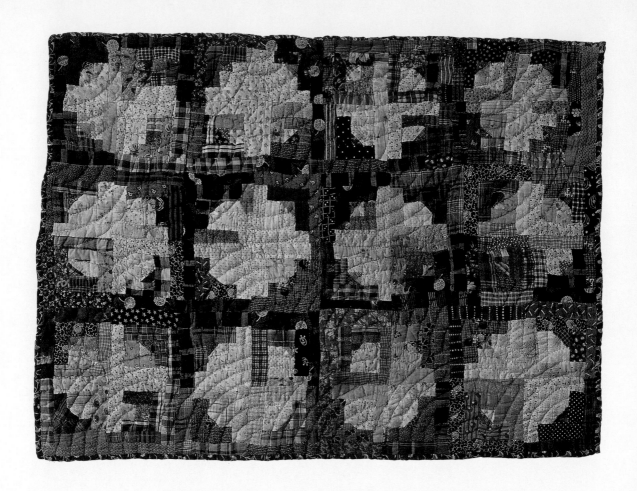

Log cabin, 1886. Clara Belle Vanderheyden was eight years old and living in Jo Daviess County, Illinois, when she pieced this capitol steps variation of the log cabin quilt. When she moved to Iowa, she quilted it in a clamshell curve—unusual for a log cabin quilt. Grout Museum. Rod VanderWerf photo.

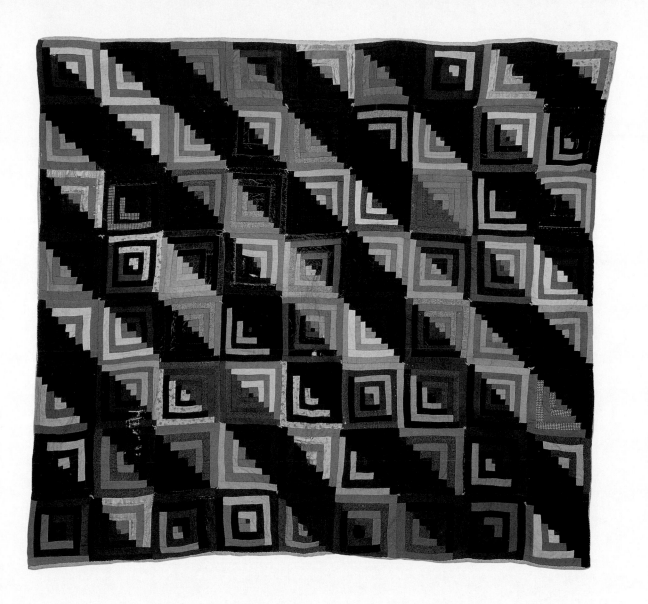

Log cabin, 1885–1900. This straight-furrow variation of the log cabin, heavy from thick batting, was made with wool from men's suits and velvet and velveteen from old dresses. The backing is well-washed cotton flannel suggesting frugality. The quilter was Alice Fox Andre, New Sharon, the author's grandmother. Author's collection. Addison Doty photo.

Triple Irish chain, 1875–1900. This was a beloved and popular pattern. This particular quilt was enhanced with beautiful wreaths quilted into the white squares. Author's collection. Rod VanderWerf photo.

Hearts and gizzards, 1890–1900. The pattern's name tells something about rural everyday life at the time. Two simple fabrics were cut, pieced, and quilted into a dazzling design.

Author's collection. Addison Doty photo.

Schoolhouse, 1890–1900. Cheater's cloth, calico printed to look like a quilt, was used in one of the houses, polished cotton in others. Grout Museum. Rod VanderWerf photo.

Helen Jacobson

HELEN JACOBSON learned to sew on the family's treadle machine when she was in the fifth grade. "I learned right away," she recalled. "My dad let me buy fabric that was economical. He wouldn't let me buy a new dress. One of the first things I made was a circle skirt."

When Helen married her Maxwell High School sweetheart, Don, they had little extra money. "The first thing I purchased was a sewing machine. I bought it on time. My dad came undone. I paid five or ten dollars per month."

To Helen, the sewing machine was like a close and dependable friend. Almost unconsciously, she started quilting with it. This was ironic, as quilts had not been a part of her family legacy. "My mother came from a poor family," she recalled. "As adults they looked at quilts as being for poor people who couldn't afford to buy blankets. It was a stigma. Quilting was for poor people. Mother didn't have time for quilting. She was sewing clothing for five children out of feed sacks and feeding the hired man, feeding chickens, gathering eggs, and gardening."

Helen, one of four girls, grew up "at a time girls stayed in the house. We had to do girl chores: feed the chickens, bring in cobs for the stove. Chickens were considered a girl job. When I married a farmer, he said, 'I don't like chickens,' so we haven't had chickens." After her marriage, Helen was kept busy raising four children and "having my turn at the combine" on the family's Story County cattle and grain farm. After the children graduated from high school, she started taking classes in

67

quilting, learning to hand-piece and hand-quilt, but she still preferred machine-quilting.

"It was a natural thing," she said. "If I could sew a straight seam by hand, I could do one on the sewing machine. I prefer the sewing machine. I like mechanical things. I had made a baby blanket on the machine for my oldest son in 1958 and didn't realize it was a quilt." She had stitched hand-embroidered blocks together on the sewing machine.

After her mother died in 1988, Helen found a dogwood blossom quilt that her mother had been appliquéing with the aid of a kit. "A kit was frowned upon in the quilting world because there was no designing," she recalled. "You did what they told you. It made me teach myself to appliqué. Everything was outlined and numbered. I had to match the numbers with the pieces and then appliqué each piece on. I loved the finished product."

The experience with the preciseness of the kit was another component propelling her toward machine-quilting and ultimately toward designing quilts on the computer, in its way a modern-day kit. "It takes longer to piece by hand than on the machine," said Helen, who blends nonstop energy with intelligence. "There are quilters who can hand-quilt as fast as on a machine. A good piecer holds her needle still and works the fabric. I've never figured out how they do that. I wish I'd learned to do it that way the first time."

She works in a comfortable tree-shaded house on a working farm on the road between Collins and Maxwell. With her sewing machine and her computer, she mixes engineering, math, art, and old-fashioned skill to create brilliant and complex quilts that have won blue ribbons at the Iowa State Fair. Often she hand-quilts the borders. Sometimes she will mat the piece by cording around the edges. "You know how you use color in the coloring book. You work black around the edge, and it makes it nice. You have to be able to sew straight and narrow."

Helen particularly likes to make miniature quilts—from postcard size up to twenty inches square. She pointed to a storm at sea pattern in miniature. "I got it out of a magazine," she said. "If I don't like it, I can go to the computer and make the size I want." She once had a commission to make a quilt sixteen inches square or smaller. "I went to the computer and told it I wanted blocks two and a half inches, and the computer told me the paper size for the quilt's foundation." She picked up a piece of paper with the exact lines of a quilt pattern. "It prints the paper. You sew on the paper, and that's that."

Helen's software includes many patterns. "I tell it the size of the block I want, and it'll print it off for me. I can draw blocks I want, and it will print templates. The computer will print out how the quilt will look when it is finished. It will tell me how many yards of each color if I want it to. I still have to cut pieces of fabric and put them on the paper and then sew on the machine. It's lots of work, but it makes it accurate and small." She picked up tiny triangles of fabric that she was working into a pattern as if she were making something for a dollhouse. She put the pieces down on the paper to demonstrate the miniature world in which she works—one that would be too tedious and painstaking for many.

Thrilled to have this proficiency, Helen said, "The computer is changing the quilting world a lot. We're going to see a lot of fabulous quilts created because of it. It's exploding the possibilities in quilt designs."

Some hand-quilters might not agree with her, as there is an ongoing dispute between those who quilt by hand and those who quilt on a sewing machine. "The people who do hand-quilting don't think machine-quilting is of equal value," Helen admitted. But that attitude is showing signs of change. "Five years ago someone won best of show at an American Quilt Society show with an all-machine-made quilt. Then at the Iowa State Fair a machine-made quilt won best of show. It does take expertise to do a machine quilt and do it well. It's a change, and we all drag our feet with change."

Even though a sewing machine isn't as portable as a sewing box, Helen often puts her sewing machine in a luggage carrier and drives to group quilting meetings. Sometimes the Iowa Quilters Guild of fifty or more machine- and hand-quilters will stay in the dorms at Iowa State University, then set up their machines in the Scheman Building. At other times they will go to Camp Hantesa with sewing machines, sewing boxes, and sleeping bags. "We stay three days and just sew," Helen said.

She is a compulsive buyer of fabric, especially 100 percent cottons. "If I see something I like, I'll buy it whether I have reason to or not. Next week it may not be there, so I put it in my stash." She piles her fabric into drawers and closets according to color. Bright prints are among her favorites.

A Ping-Pong table in the basement serves as her workbench. "My machine is never put away," she said. But she does stop at noon to make a traditional midday farm dinner for her husband and son, Larry. "They're talking markets and weather, and I have to look interested," she said. Father and son farm almost two thousand acres— owning some land and renting some. Her job is to do the taxes. "Farm work has changed so much in the last ten years. Computers, combines, and tractors. It's unreal to keep up in farming today."

Her husband asks her to be more involved in the farm work, in decisions, but she much prefers going down to the basement and cutting tiny cloth triangles. "I take the sewing machine as far as it will go," she said with a tinge of pride.

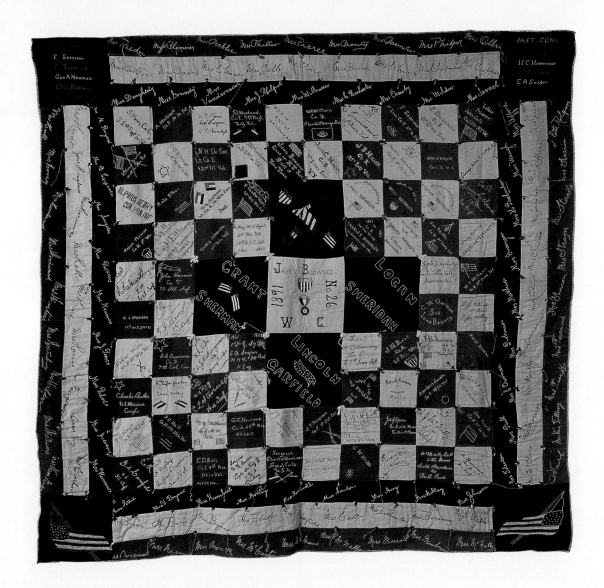

Civil War quilt, 1891. Cedar Falls women made blocks to commemorate friends and relatives who fought in the Civil War. Deaths, wounds, and blindness were detailed in the embroidered blocks, giving us an up-close history of the war's tragedies. Grout Museum. Rod VanderWerf photo.

Basket of flowers, 1890–1915. This cheery red, white, and green quilt may have been made to bring out at Christmas. Author's collection. Addison Doty photo.

Cherries, 1890–1915. Different-colored threads are used to outline the appliqué. The cherry leaves are an extremely faded green. The quilter stitched around the leaves with green thread. The backing is white with a tiny print typical at the turn of the century. Author's collection. Addison Doty photo.

Bread basket, 1900–1915. Christmas colors were used attractively in this basket quilt.
Author's collection. Addison Doty photo..

Rambler, 1900–1920. Blocks work together to construct an intricate overall design in this quilt. Author's collection. Rod VanderWerf photo

Ruth and Ivan Johnson

❋ IT ALL started in the 1920s when, as a small child, Ruth Vaughan stood in the family's modest Ogden house and watched her hard-working mother quilt—sometimes by the light of a gas lantern—so there would be enough blankets for the beds. Her father was a carpenter with nine daughters and one son to feed and clothe.

"We were poor," said Ruth, her face so embedded with lines of work that her earnestness did not crack for a minute. "She had to make stuff to cover the beds with. She was always working on something and taking care of ten kids. She taught us all how to sew and piece and quilt. What she made was left over from clothes. You didn't get to go to town and buy a bunch of fabric. We made clothes and learned to knit and crochet. We didn't have money to go anyplace or just to spend. We didn't have much, but we always had lots of love in the family. We had to do for ourselves. Mom and Dad were there for us."

Gradually Ruth started helping her mother piece quilt tops, something she was glad to do, for she was contributing to the family's welfare. Never liking school, she was happy to supplement her family's income by working as a waitress at the Mayflower Cafe in Boone after she finished the tenth grade. While working, she met Edward Ricke, a farm hand. After marrying, they moved to Wesley, his hometown on the quiet prairie of Kossuth County.

That was 1941, and they lived in a two-room house without electricity or running water. Edward worked double-duty as a blacksmith, repairing farm machinery, and as a farm hand. For several years, Ruth stayed home with her children and didn't work. Later she "helped pro-

vide the living 'by cooking at Loebigs'," a Wesley cafe where she made "whatever anyone wanted" and became renowned for making the best pies in the county. She also packaged powdered milk at a plant in Britt. When there was time, Ruth pieced and quilted by hand, a necessity because the lack of electricity made quilts for the beds indispensable. "I was always doing something. I still am," she noted while standing, which she seems to do more than sitting. "I can't sit still."

She made her quilts in the old-fashioned manner, often using patterns from magazines. "I cut the pattern out of cardboard and traced around that onto the fabric and then cut it out. I didn't have all of this fancy stuff. Later I got a sewing machine and pieced the tops by machine. I still don't do the actual quilting by machine. I've tried it, and I don't like it. I think hand-quilting makes the value of the quilts better."

In 1964, at the age of forty-four, Edward was killed in an automobile accident. Ruth was suddenly a young widow and mother of three. She got her bearings and returned to work at a Wesley restaurant. It was up to her to support the family. Eventually she went to work at the Winnebago Company. "I made dashes, stuffed cushions, and made arm rests—a little of everything," she brought up wearily. She did this for fifteen years, sometimes even when the side effects of back pain from grueling work were fierce.

"I'd get up at 5 A.M. and sew quilts and go to work about 6," she recalled with a sigh. "I had made quilts all my life. It was something I liked to do. It was relaxing and still is. It set the day positively. I never knew what to expect at work. I quilted at night if I was not too tired."

Through the years she became good friends with her neighbors, Ivan Johnson, a farmer and builder, and his wife, Mildred. Mildred and Ruth were so close they thought of themselves as sisters. Sometimes Ruth babysat for the Johnsons. In 1983, Mildred died. Ivan and Ruth continued their forty-year-old friendship, which eventually led to marriage. Ruth continued her quilting. Ivan watched. "Two years later I got him to cut pieces of cardboard. He got so far ahead of me I

got him to cut quilt pieces. He got so far ahead of me that I told him to start sewing. He didn't balk. He thought it was kind of fun."

Ruth selected a giant dahlia pattern as a starter for Ivan. "It wasn't a pattern he would have picked out," Ruth recalled, smiling. "I told him to make it. It didn't go together right. He was going to throw it out. Then he was going to finish it. It was all on curves—something a beginner shouldn't start out on." It didn't daunt him. He made a fancy cutting board and cut cotton pieces for both of them.

Handiwork wasn't exactly a new talent for Ivan, a large man with big hands, who was used to pitching hay and driving a combine. Mildred had taught knitting in evening classes at Corwith High School. Along the way, she taught Ivan to knit, and as a pastime he knitted afghans and sweaters. "He was a perfectionist in anything he did," Ruth remembered. "His farm machinery was well kept. Anything he owned, he took good care of." He had also done some woodworking—another art enjoyed by perfectionists.

Ruth and Ivan set up sewing machines next to each other in the living room of his spacious contemporary home on a farm north of Wesley. They looked out at a bird feeder and beyond to a flatland of rich black soil and green cornfields. They listened to records of hymns and country music while they worked.

Sometimes Ivan, after working in the fields all day, would sew until 9 o'clock. During the winter, when there were minimal chores, he sewed all day. His specialty was laying out pieces of his hand-selected fabric into intriguing designs and sewing them into blocks. He did some hand-quilting, but he couldn't keep up with himself and sent quilt tops to the Amish to quilt.

He collected fabric like some people collect old bottles or nutcrackers. "Anyplace we'd go, he'd buy fabric," remembered Ruth. She pointed out the heaps of fresh cottons in two bedrooms, noting that she had even given some away. Looking at the fabric brought up memories about their quilting ventures.

"We'd argue over what colors to use. We'd get a bunch of fabric and lay it on the floor or table. If it wasn't right, we'd get some more until we found what we wanted. Ivan liked to work with black. I didn't. It was hard on my eyes. I'd use other colors. He'd use black. Maybe it was getting associated with the Amish people down in Kalona. He liked the colors with black."

Ivan's own designs were so successful that some were printed and marketed by an Iowa quilt store. "He would take pictures of quilts and come home and draft them," said Ruth. "I'm not that talented. I had to have something to go by." In three weeks, Ivan could create and put together a complex quilt. In his fifteen years of quilting he made three or four hundred quilts, many of which were exhibited in the nearby Grout Museum in Waterloo and some as far away as Japan. "He was proud of his quilts," said Ruth. "He got lots of compliments."

Ivan's compulsiveness about quilting never dimmed even though he was often uncomfortable while he created and stitched. His back had been seriously injured while serving on three fronts in World War II, and he was in constant pain. "It bothered him all the time, but he wouldn't give up," said Ruth. One day in the summer of 2000 Ivan was at his sewing machine. He took a break while his son visited, but shortly afterward he had a massive heart attack and died. Ruth can't remember which quilt he was working on. "I put it in a box and haven't gotten it out," she whispered.

Without Ivan, Ruth's quilting habits have changed. "I have to do all the cutting now," she explained. She has had to quit the actual quilting of her piecework, letting the Amish do it instead. "I send fronts and backs and batting and they do their own thing."

Her style is also changing. She used to use white as a background color. "I like using colors for the background now, like in older times." But she still stitches pieces together every day.

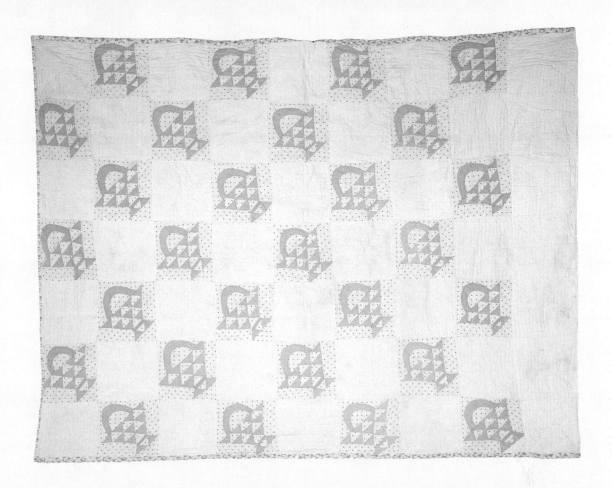

Cherry basket, 1900–1920. Pink baskets have a background of the white-printed calico so popular at the turn of the century. A yellow and white floral print fabric makes a contrasting backing. Author's collection. Addison Doty photo.

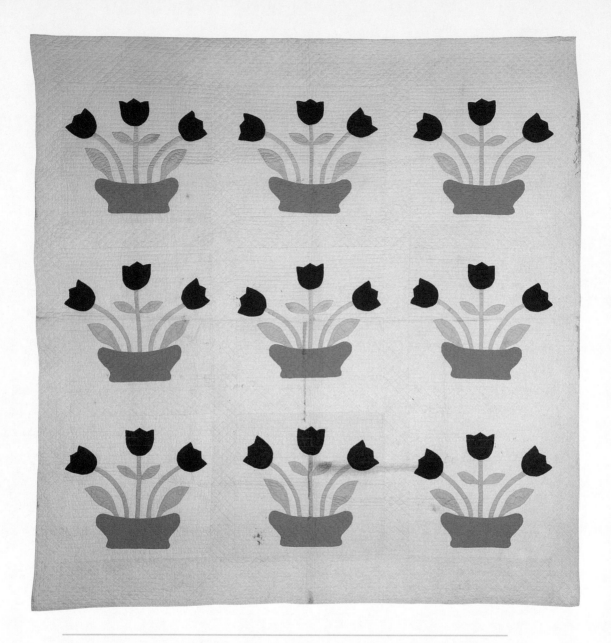

Tulips, 1900–1920. Tulips have always been a popular motif, particularly in Iowa, home to several Dutch settlements. The quilting on this work is extraordinary with small and close stitches. The pencil marks still show, as the quilt has never been washed. Author's collection. Addison Doty photo.

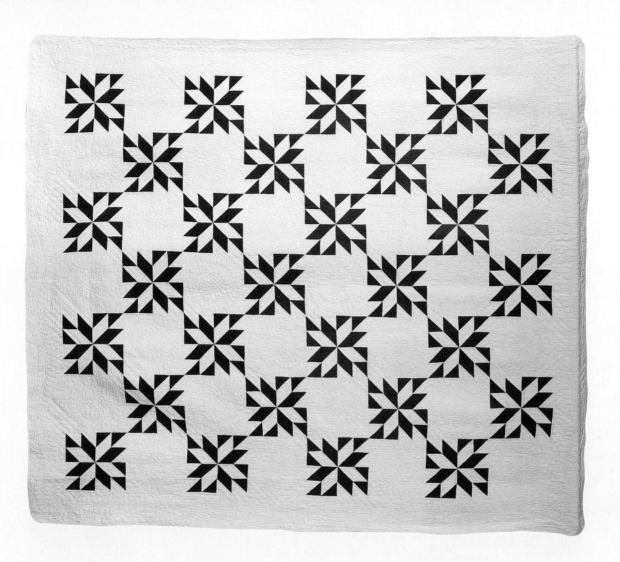

Anna's choice, 1890–1925. Finely quilted wreaths decorate the plain blocks of this quilt.
Grout Museum. Rod VanderWerf photo.

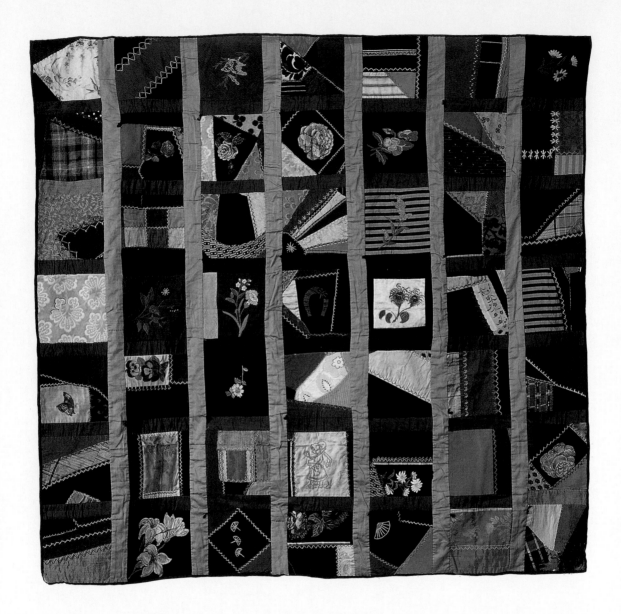

Crazy block quilt, 1890–1925. This crazy quilt is refined, as each block was individually fash-
ioned and then sewn onto the backing. Grout Museum. Rod VanderWerf photo.

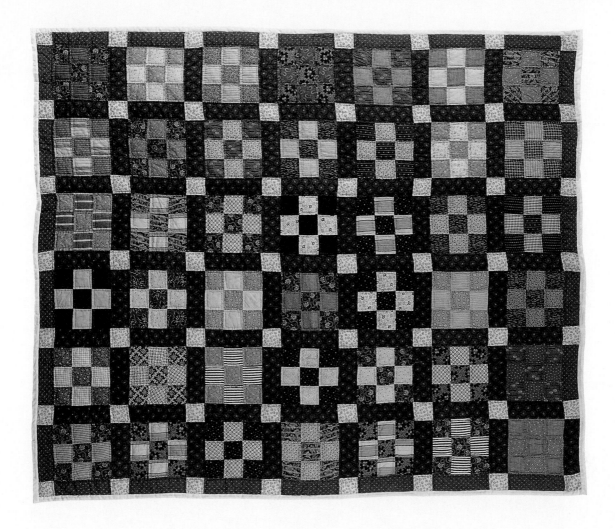

Nine patch, 1890–1925. Fabrics from Iowa's German Amana Colonies were used in piecing the quilt top. The top was quilted more recently by Iowa Amish. Author's collection. Rod Vander-Werf photo.

Gibson Furnaces, 1900–1925. Wool felt logos for Gibson Furnaces, owned by David Gibson, Waterloo, were stitched together to make a coverlet. Grout Museum. Rod VanderWerf photo.

Ethel Taylor Jordan

SCRAPS were scarce when Ethel Taylor was growing up on a small rented farm in Wayne County, and the few the family accumulated were stockpiled for making quilts. But Ethel loved to sew. "When I was about five, I'd take scraps from Mother's sewing pile, and needle and thread, and I'd hide under the bed and make doll clothes. I wasn't supposed to be using the scraps. My mother used egg money for thread. I knew it was expensive. That's why I hid under the bed."

There were nine children in the family. Out of necessity, Ethel's mother quilted at least two quilts during the winter. "When we girls got old enough, we did the piecing," Ethel remembered. "Just by being there, you learned how."

Ethel opened the closet in the bedroom of her tidy house on a tree-lined street in the center of Corydon. She carefully unfolded and tenderly shook a slightly faded hummingbird or snowflake quilt, its edges fringed from use. She said she was in grade school when she sewed the tiny pieces of already-used feed sack fabrics together into the intricate design. She turned the quilt over and proudly showed off the backing—red roses on a white background. She remembered going with her father to the feed store to buy chicken mash one Saturday a long time ago. It took three bags of mash for the backing. When she was in high school, her mother quilted it for her.

Embracing the quilt fondly, she said, "This one went with me when I went to Kentucky to teach for two years. It went to Sterling, Kansas, when I finished college. It's just the right size for a single bed." It has always been her favorite quilt. She went over the quilt and marked the

origin of the fabric pieces—her mother's apron, her dresses. She pointed to a blue-checked patch. "That was my freshman in high school home ec dress."

Next, Ethel pulled out a flower garden quilt made from the hundreds of cloth petals she cut and pieced while in high school. "I worked on this off and on for four years," she recalled. "It wasn't anything I had to hurry with . . . just if there was time." That time was after school and on Saturdays. Her mother quilted it in the 1940s.

Fabric from feed sacks was critical in quiltmaking in those days. "Papa couldn't go to the store and buy feed without one of us girls," Ethel reminisced. "If you were the one who needed material, you got to go."

Ethel was born in 1924 in Minneola, Kansas, where her father was a wheat farmer. The Dust Bowl forced them to Iowa and a new life in 1939. They first rented a small farm; later, they bought eighty acres. "We raised what we ate," said Ethel. "We always had time for fun. Even when we were hoeing in the garden, we had fun."

Everyone in the family had to work hard just so there would be enough to eat. "We girls worked in the fields during the war. We'd put timothy and oats into shocks and stripped sugar cane. I used to drive horses when they put hay in the barn. I herded cattle when I was young, and we all helped with chores—we fed the stock and milked. It was hard work, but it didn't seem to hurt us."

After graduating from Allerton High School, Ethel attended summer school and taught for five years. She then attended Sterling College in Kansas where she met her Pennsylvania-born husband, Ralph Jordan, a Presbyterian pastor. They have lived in Pennsylvania and in little towns throughout Iowa—Le Claire, Middletown, and Grand Junction. For thirty-four years Ethel taught school while also helping her husband with his various church duties. In later years, Ralph became blind and struggled with depression. Ethel picked up her quilting and stitched away difficulties that might have overwhelmed some.

"It was good therapy while my husband was ill. It gave me a lot of contentment and joy."

During this time she created an heirloom quilt with twenty blocks of appliquéd lifelike flowers—arrangements and crowns. She worked the printed fabrics like paint to shade the flowers to reality. "A lot of flowers came from my flower bed," she said. "I copied them." She pointed to a block of realistic-looking pansies. "I ended up with lots of pieces which had just holes. I wanted certain colors. I could carry it with me and work on it in airports and hospitals. Ralph was in the hospital then." It took her three or four years to create the award-winning "My Garden Album."

In 1992, Ethel and Ralph moved to Corydon, which, to Ethel, was going back home. She immediately got involved with the International Center for Rural Culture in Allerton, focusing on a project to preserve a 1912 round barn. "I went right into that world," she said. "I wanted to be involved in the community and to give back." For five years she has been president of the center's board. She has worked on the project daily. "It has involved telephone calls, janitorial work—I have put in hundreds of hours. We need to keep some things we're blessed with and give back for future generations," she said.

Ethel stopped talking and spread out the striking star quilt, "Stars over the Heartland." She created the quilt to be used as a fundraiser for the round barn. The quilt was auctioned for a thousand dollars, but no one claimed it. "A note was attached to it that said it was to come back to me," she said, smiling modestly.

The greatest tribute to her as a quilter may have been when she was asked to quilt the Iowa sesquicentennial quilt. Quilters around the state had created original blocks to represent each of Iowa's ninety-nine counties, and the Des Moines Quilters Guild put the blocks together. Ethel was asked by the Iowa Quilters Guild to do the actual quilting. She used 1,296 yards of thread and worked 403 hours in the community room of the Wayne County Courthouse.

89
✳

"I worked on it for five months," she said. "It was consistent work. I received the quilt top in June 1995. I spent three weeks studying the top, reading Iowa history, finding resources—both people and patterns—and then marking the tan border. Except for the rose leaves, the quilted patterns were my own or were adapted from resource material. The quilting on the county blocks varies as much as possible. In some I could only outline the designs. In others I could quilt in traditional patterns like the cable, feather, grids, stars, leaves, and clams. One block lent itself to the Iowa star quilt pattern.

"In the tan border I quilted in objects that represented the state and history. The stars are in memory of and dedicated to the men who gave their lives for Iowa land and people. The cornstalk has been the source of life for all Iowa people since the Indian nation lived and farmed along the eastern border. The boy sitting under the oak tree hooking a fish with a cane pole speaks of past pleasure and future opportunity. There is a butterfly for the gift of life and the goldfinch for the beauty in Iowa's nature, and you'll find the notes for the Iowa corn song! The clay pot expresses the artistic ability and resourcefulness of the Indian nations. The eagle and eight-pointed-star patterns were taken from the quilts the Lakota ladies make."

Today the center of Ethel's quilting activity is a small bright bedroom in the back of the house. When she is engrossed in a project, she quilts six hours a day, all the while thinking of her family, her husband, and the comfort of being back home in a small Iowa town.

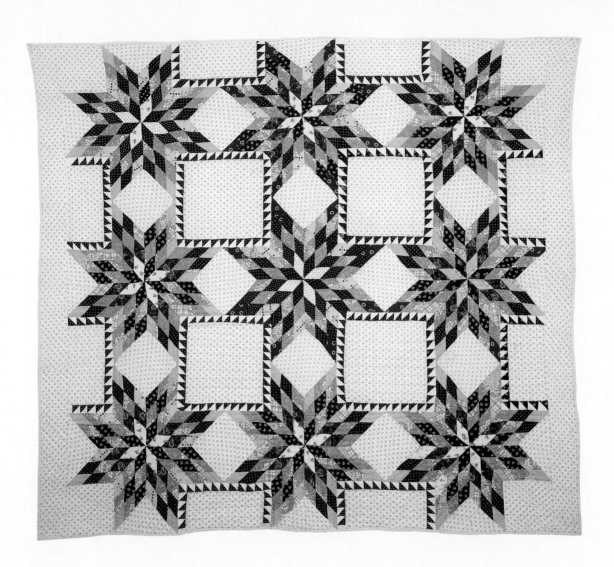

Star upon stars, 1920. This quilt design is a busy one. Author's collection. Addison Doty photo.

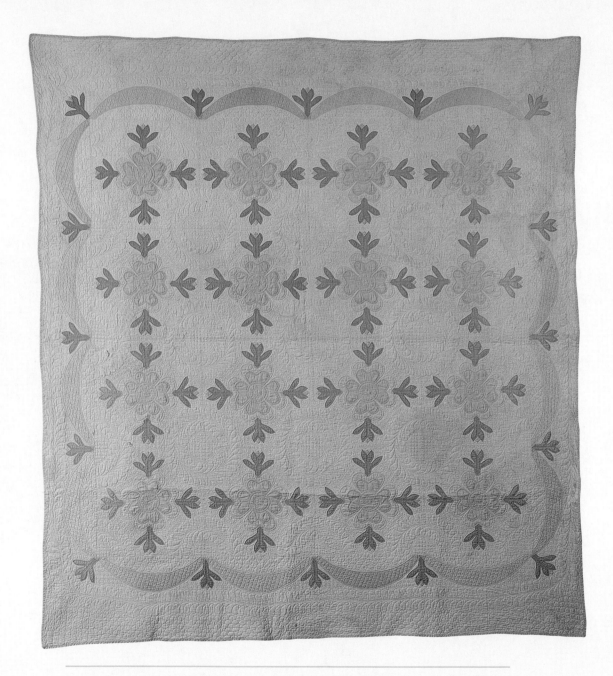

Rose quilt, 1920–1930. An elegant rose appliqué was enhanced further with meticulously quilted wreaths. Author's collection. Rod VanderWerf photo.

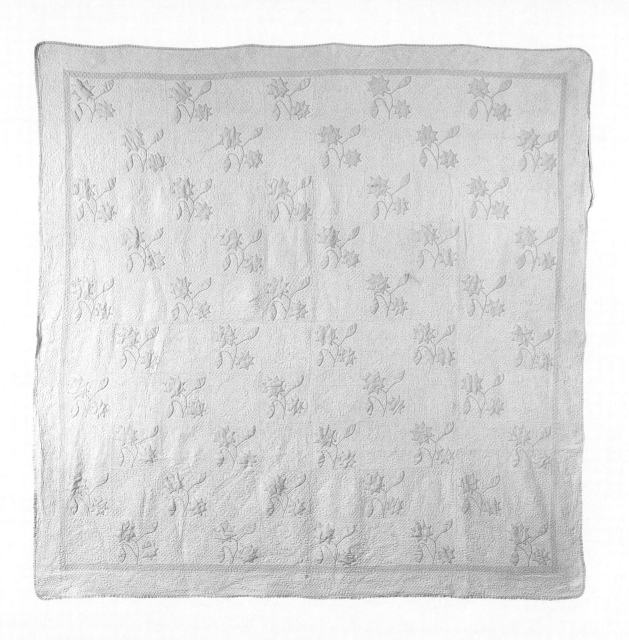

Flower appliqué, 1920–1930. Delicate stitching transformed simple cotton sheeting into an heirloom. Author's collection. Rod VanderWerf photo.

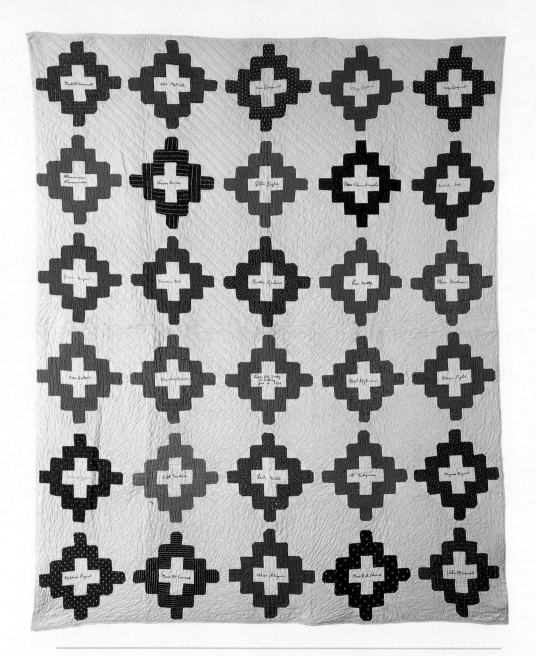

Album quilt, 1926. The Ladies Aid Society of the St. Anthony Christian Church made this quilt for a raffle to raise money for the church. Rose Baston, the owner's great-grand-mother, was one of the signers. Collection of Roxanne Mehlisch. Rod VanderWerf photo.

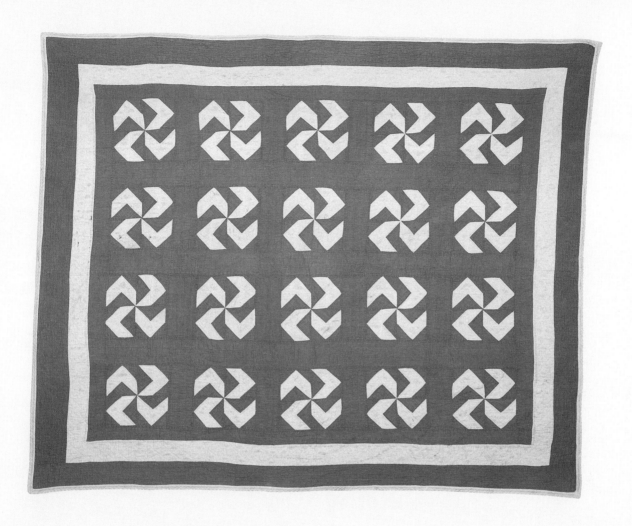

Fly foot, 1920–1930. This simple design was popular in the early 1900s. Author's collection. Addison Doty photo.

Sara Miller

IT IS ONE of Iowa's notable summer mornings. The sweet smell of newly cut hay permeates the air. A carpet of sturdy corn plants inches its way upward toward the cloudless sky. Beyond, the Iowa River Valley is dotted with stately basswoods and willows. Simple farmsteads with big white barns interrupt the deep green of the landscape. Clothes, hanging on taut lines, ripple in the trivial breeze. Ahead a horse and buggy tilt on the roadside as if hanging in space. A handmade sign says, "For Sale: Sundries." This is Amish country.

Printed in black on a barn are the words Kalona Kountry Kreations. Inside, Sara Miller, gray hair pulled back under a sheer white cap, surrounded by rolls of multicolored quilting fabric, is talking to a fabric salesman. Next to the counter is a quilt frame holding a quilt, unusual in that it is all pink. "This lady wanted pink all over," said Sara, not giving any hint whether she approves or disapproves. "We'll have to make pillow shams to match. I don't know how long it'll take. We'll do it in our spare time. It'll take quite a while. Whoever the worker is sits and quilts."

Sara, who has the heartiness brought by years of difficult work, exudes common sense with contemporary awareness. She grew up in an Amish community near Kokomo, Indiana. In 1952, at the age of eighteen and with only one year of high school, she came with her parents to Kalona, an Amish settlement south of Iowa City. Her brothers had settled there previously and liked it. "This farm was for sale, and they bought it and set to work," Sara remembered.

To do her part, Sara took care of babies, frosted rolls in a bakery, cleaned houses for twenty years in Iowa City, and eventually helped in an antique shop in Kalona. She and her mother also quilted for a store in Kalona called Kountry Kreations. In 1976 her father died, and her mother had serious heart trouble. "That's when I bought Kountry Kreations and a bought-fabric business from a widow," recalled Sara matter-of-factly. "That's how I got started." She worked so hard quilting for others and selling quilting supplies that she became recognized simply as "Sara, the Amish quilter at Kalona." She explained, "I had worked in a shop and that taught me. I didn't finish high school, but I've been educating myself since."

For years, Sara's brother, who had left the Old Order Amish Church to become a Mennonite, did her banking for her because he drove a car—something Mennonites permit. Sara had a horse and buggy most of her life, but in the early 1990s she gave them up. "I made a change and joined the Mennonite church," she said. "I love it. Now I can buzz down to the bank in the morning before the store opens. When I look back, I don't begrudge my former years, but I'm glad I don't have to get the horse and buggy out." She explained that the basic beliefs of the Mennonite and the Amish worshipers are similar. "The difference is the way we do things—the mode of travel. I have electricity and a telephone." She dresses with Old World modesty but not as traditionally as the Amish. Today she is wearing a long turquoise dress with her simple white cap.

Sara grew up with a quilting frame in the living room. She was a young girl when her mother taught her to quilt—emphasizing fine stitches—although she admits that she would have rather been out playing with the boys. "She was a patient lady or I wouldn't be where I am now, especially when it came to piecing." Her first quilt was a simple four-patch. "I didn't like the dark Amish quilts so my mom let me do a nontraditional one out of printed feed bags."

In her later years she started collecting Amish quilts, another change, for growing up she did not like traditional Amish quilts. "All we had were the old dark quilts," she recalled. "I thought they were terribly ugly. After my parents were no longer alive, I got interested in Amish quilts and thought I'd like to have one. Then I bought one and began to deal with them before I collected any. Sometime after that I was asked to come to different places and give lectures and show what I had."

Because the large quilts were inconvenient to carry when she was traveling to give lectures, she began collecting crib quilts. "You don't pack quilts and check them when you fly," she said. "I carry them. I thought I'd do small ones so I'd have more examples to show." The collection is decidedly hers. "None of my quilts is spectacular. I wanted light colors—not dark. They're not traditional."

Her shop and barn sit on the eighty-acre farm she bought from her parents, which makes it doubly difficult to contemplate selling the shop. But she's tired. "I feel I should dispose of things while I'm able and not wait so my brothers and family have to dispose of everything. What hurts is the closing out. In the last ten years people have come to depend on us. If someone wants even half a yard, I'm on the phone right away. The whole town of Kalona will suffer."

Sara has always taken an interest in everyone who has stopped in the store, which is one reason people from all over the world write to her for quilting supplies. She can't guess how many quilts she has quilted through the years. "I wish I would have kept track. We quilt for a couple of people now," she said. "They bring in tops, and I don't have the heart to say no." She has always used the standard patterns. Her long days end with a simple supper in her house next door to the shop. Evenings, she'll sit down and piece simple nine-patch tops that will be sent to families in Romania.

"At this time a year ago my brother and wife and niece and I were on a train to Bucharest," she explained. They went to work for the

Christian Aid Ministry, part of the Mennonite church that sends food and clothing to families in Moldavia, Ukraine, and Romania. "When I saw the need and came home, I made a contest. I wanted to do 100 tops by spring. I did 114. Friends helped with 10. I sent 90 tops with backs. We sent comforter kits—enough for one top and backing, but they have to piece."

Sara is doing this to help others, an innate characteristic of hers, but she also likes working with fabric just as she has always done. "I don't want to be a proud person, but I'm pleased. I've had divine help. I couldn't have done it on my own. The Lord has blessed me."

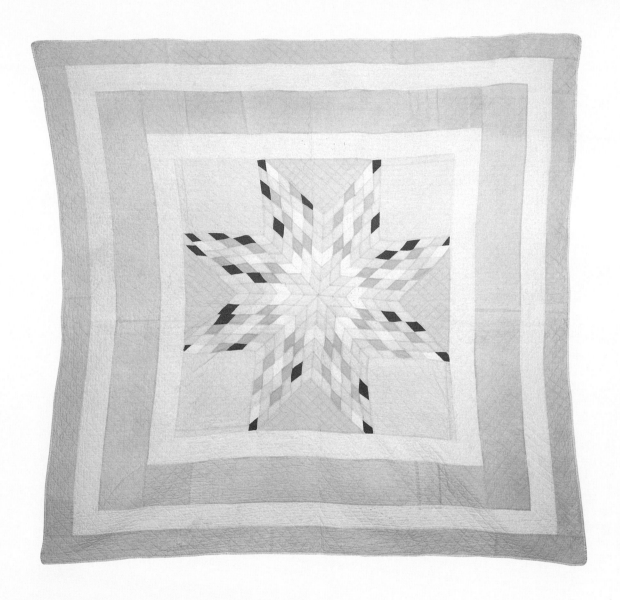

Star of Bethlehem, 1920–1930. Muted much-used fabrics create an inexpensive and quiet quilt. Author's collection. Addison Doty photo.

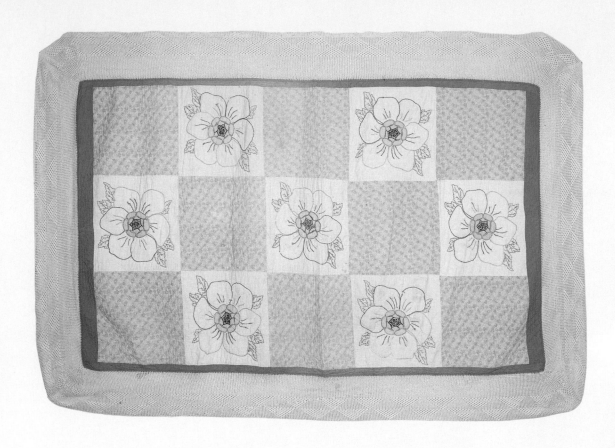

Rose, 1920–1930. This quilt was embellished with embroidery on the appliquéd roses. The maker obviously was proud of her needlework talents and made the quilt even grander with wide crocheted borders. Author's collection. Addison Doty photo.

White quilt, 1920–1930. White quilts have always been coveted. This whole-cloth white quilt, created out of simple cotton sheeting, is exceptional with its magnificent quilting. It is believed this quilt was made for a bride and groom from a prominent family in Independence. Author's collection. Rod VanderWerf photo.

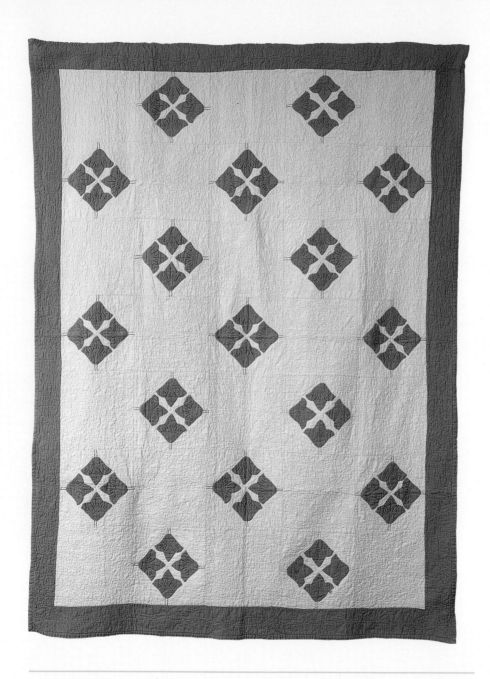

Bluebells, 1925–1940. This simple appliquéd quilt was machine-quilted. Grout Museum. Rod VanderWerf photo.

Lone eagle, 1930. A Lutheran church group in Iowa made this quilt to commemorate Charles Lindbergh's historic flight. The group initialed and dated the piece in the corner. Eagles with carefully embroidered yellow eyes are quilted onto the white spaces. Author's collection. Rod VanderWerf photo.

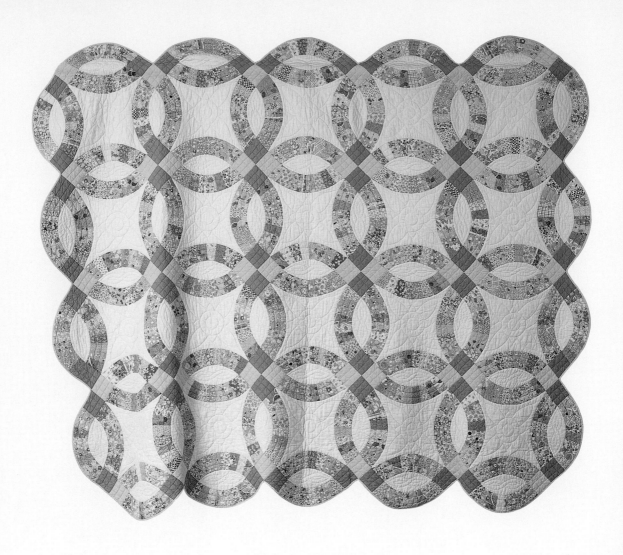

Double wedding ring, 1930–1940. The double wedding ring has always been a popular pattern in Iowa. These quilts were often given as wedding presents; at other times the bride created them in preparation for her wedding. In this quilt the scalloped edges are bound with yellow cotton. Grout Museum. Rod VanderWerf photo.

Winnifred Tyerman Petersen

WHEN Winnifred Tyerman Petersen was a child spending summer vacation with her grandparents in Canada, her grandfather took her with him to buy a wool fleece. At the end of the summer, Winnifred and her family carried the fleece home to Cedar Rapids. "My earliest memory of quilting is sitting at the kitchen table and carding wool from that fleece," Winnifred, an earnest, hardworking woman, recalled while sitting next to the street window in her Davenport house. "It was going to be a utilitarian crazy quilt. The wool was going to be the filler for the quilt."

Born in 1921 in Manitoba, where she spent her early years, Winnifred, always industrious, was taught to sew by her grandmother, who "had a treadle machine sitting in her living room by the front window. We would watch for the mailman to bring us fabric from Eaton's in Winnipeg."

Her grandmother and aunt both helped to raise Winnifred, who was six when her mother died in childbirth. Her father, a mechanic, was restless. "The grass was always greener. We moved from one little town, and there would be another. He fixed all of the cars in each town until there weren't any." She lived in Worthington and Minneapolis, Minnesota, and in Storm Lake, Pomeroy, Cedar Rapids, and Davenport, Iowa.

She met her husband, Vincent, a musician, at Davenport High School in 1939. "He had a violin under his chin and was playing. I thought, 'How wonderful.' I worked in an ice cream store, and he came in after a concert. I said, 'How wonderful,' and he got inter-

ested." After he took a job at the Davenport Arsenal, they made their home in that city.

When she was in high school, her grandmother had given her a pink flower basket quilt. "It was much loved and has long since been worn out and gone," Winnifred remembered. "In the back of my mind I had a desire to make a quilt of my own."

The thought did not fade while the years did. Through the years Winnifred sewed her own clothes, but she did not pick up her quilting needle until she was "ordered" to in 1973 while working as the Evangelism secretary at St. John's Lutheran Church in Davenport. "The ministers felt we needed small support groups," she recalled. "They wanted me to start a quilting bee. When the minister said, 'Do this,' I did it. I really didn't know what I was doing at the time, but I got a lot of enthusiastic help. We got the ladies together and started to work. Some knew exactly what to do and helped the rest of us. It didn't take us long to get going. People would bring in tops, and we'd put them together, quilt, and bind." Winnifred quilted tops, read books on quilting, and learned from the experienced quilters.

The group got together once a week for twenty-three years. "People were happy to have someone to be with. There was a group of ladies who didn't want to quilt so they'd embroider quilt blocks and bind them together. They were part of our group, yet they didn't quilt. Part of it is sitting around a quilting frame and visiting. They'd tell secrets they wouldn't tell otherwise. There was not gossiping. There was sharing."

Winnifred eventually became well known for her knowledge of the art of quilting. For twelve years she taught at Scott Community College. She spoke to women's clubs and civic groups about quilting. She presented a program on designing quilt patterns for the Mississippi Quilters Guild. For the group's fundraiser, a booklet was made from her notes and illustrations.

The pieces made at the church were old-fashioned bed quilts. In a way, making blocks, stitching them together, and planning quilt designs was training for the stunning mosaiclike works of art Winnifred creates today. She no longer makes bed quilts. "I do challenges," she said. "I do it the same as someone who paints a picture. I do it for the joy of creating. I enjoy looking for interesting elements in pieces of fabric, cutting them out with precision to form a unique wall quilt." With her innate attitude that nothing is too difficult, she constantly pushes herself to make more complex quilted wall hangings, often from almost microscopic pieces of fabric.

A few years ago at a national quilt show, a merchant had a bolt of fabric that he could not sell. He thought the colors were ugly; so did everyone else. He challenged quilters to take the fabric and create something beautiful. Winnifred was one of thirty to sign up then, but more signed up when an ad for the dare was printed in a magazine. Winnifred's design blended the seemingly funereal black, blue, orange, green, and gold print into a stunning, antique-looking churn dash quilt featuring churns made of two hues reflecting the colors in the print. The fabric company chose her quilt to tour with a few others created using the same print.

Winnifred draws her original designs on paper, then takes a see-through template, puts it over the fabric, and cuts her pieces. Because her stitches are minuscule, she hand-sews over paper, English-style. Often she works with hexagons, for which she is acclaimed, bringing a bit of grandmother's flower garden into each quilt. ("There's been a grandma's flower garden in every quilt show I've ever gone to," she stated.) She sometimes painstakingly cuts and pieces together quarter- or half-inch hexagons, giving a stained glass effect to the quilt.

In a way, Winnifred's quilts are like arduous, mind-challenging puzzles. She made one small (20 by 26 inches) quilt from fabric reproductions of the early twentieth century when small-print designs were

in vogue. There are three thousand hexagons in the quilt. "Look at those tiny butterflies—those teeny dogs," she said of the fabric pieces.

Crazy quilts also pique her curiosity. Did this interest have its genesis when, as a child, she watched utilitarian crazy quilts being made? "It's part of quilting. The thing about crazy quilts is they can be so personal—a pillow slip, a cover for a footstool." Recently she created a complex and involved crazy quilt, using a sampler of stitches. On the back she labeled the stitches as a reference for herself and others in the future. She looked at it and commented casually, "When you're doing embroidery, it depends on how you're holding the needle. You hold the needle differently and get different stitches. I try to take the needle and fabric as far as they go."

Winnifred incorporates butterflies into all her creations. They appear in her quilting designs. They are appliquéd onto the front and the back of quilts. They are embroidered and cross-stitched. Sometimes they are simply buttons sewn discreetly onto the quilt. She does not know where this fascination with butterflies originated. "I purposely do butterflies. They are symbols of hope. Not immortality, but hope."

She always has with her a small brightly colored plastic box. "Quilters are great recyclers," she noted. "This is a soapbox." Inside it are a tiny hexagon pincushion, pieces of hexagon paper, and bobbins of thread. She likes the space efficiency of bobbins versus larger spools. Also in the box are tiny fabric hexagons on top of each other—right sides facing. She has whip-stitched some of the sides together with her almost microscopic stitches. "It gets to be almost perfection, which is what I aim for," she said. "I love hexagons. I think there are so many things you can do with them."

She carries the box with her so she doesn't waste time. She belongs to two book clubs. "If someone else is talking, I don't fall asleep. I sew." She is a volunteer in a hospital surgical waiting room several times a month. "While I'm there, I bring out my sewing."

Mainly, though, she sews in her chair by the window in her living room on Linwood Avenue, where butterflies in various forms hang on the wall. Noticeably, there are no quilts hanging on the walls or thrown over the sofa. Nor are there any on the beds. Someday her delicate quilt pieces will be gifts to her daughter, Lora Beth, and to friends. The quilts will be enduring remembrances of Winnifred Petersen patiently stitching the tiniest of hexagons into cloth puzzles, great pieces of beauty.

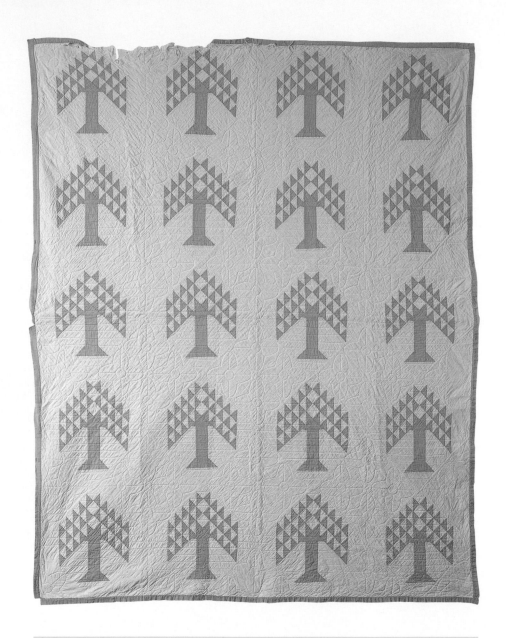

Pine tree, 1930–1940. Bertha Sampson, who lived on a farm near Roland, was eighty-five years old when she died in 1955. She left this quilt to her daughter, Carrie Anderson, who passed it down to her daughter, LaVonne Christenson, of Zearing. Collection of LaVonne Christenson. Rod VanderWerf photo.

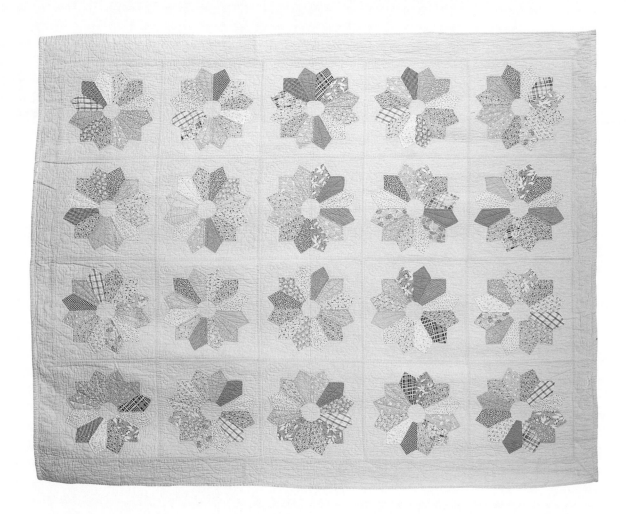

Dresden plate, 1930–1940. Many of the fabrics used in the popular Dresden plate patterns were collected from calico feed sacks. Grout Museum. Rod VanderWerf photo.

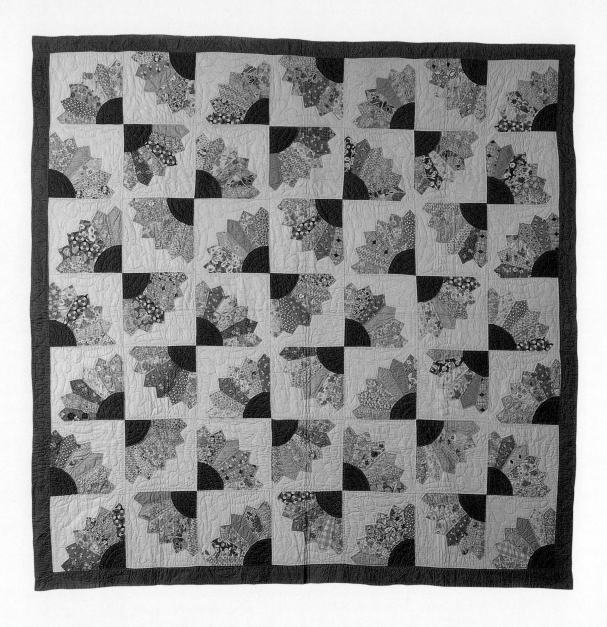

Grandmother's fan, 1935. Martha Agnes Hennis, a Minerva farmwife, stitched this quilt as a wedding present for her daughter, Dorothy Mehlisch, in 1935. Lavender was a favorite color to slip into quilts during this period. Collection of Roxanne Mehlisch. Rod VanderWerf photo.

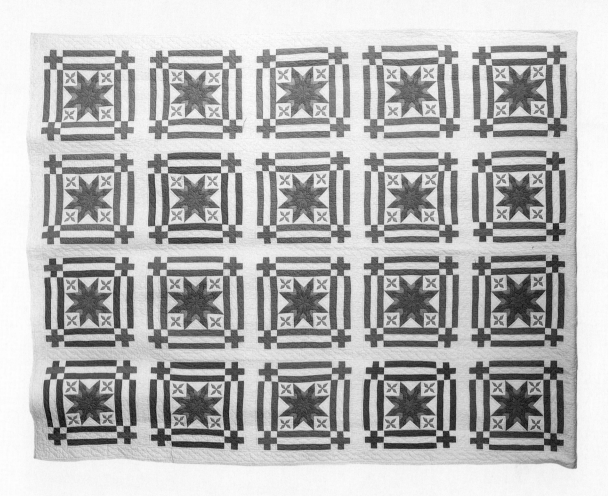

Virginia star, 1935–1940. This beautifully made quilt has cables in its sashing and borders.
Grout Museum. Rod VanderWerf photo.

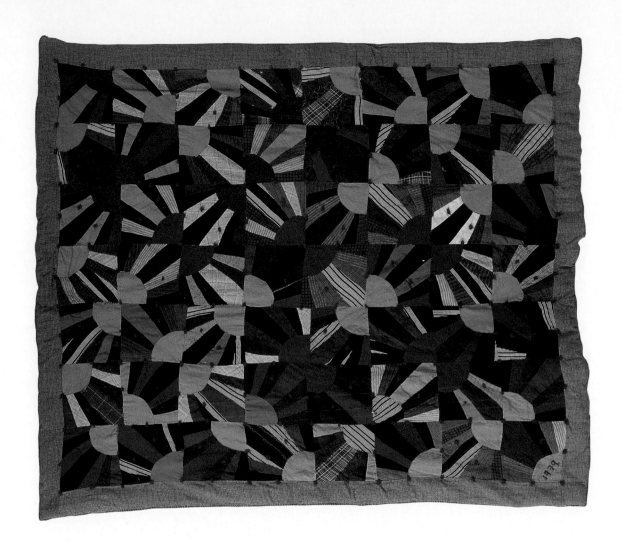

Sunrise, 1939. Pieces of old wool clothes were set together to make this warm and bright quilt. Grout Museum. Rod VanderWerf photo.

Ruth Adams Steelman

ON CHILLY mornings in the early 1900s, Ruth Adams Steelman threw corncobs into the wood-burning stove, pumped and heated the morning's water, and cooked her family of eight a hearty breakfast of fried potatoes, eggs, and side pork. Then she fed the chickens and, in the summer, planted and hoed in her garden. Sometimes she fried meat, packed it in lard, and preserved it in a big crock in the basement. Such chores were as routine as looking at the sky to gauge the weather during her lifetime with her husband, Otis, on a rented farm in the tiny wooded Quaker settlement of Illinois Grove in northeast Story County.

It was demanding to raise six children on the small income from a rented farm. Still, in the middle of the day, with morning chores completed and the children in school, Ruth wedged in time for sewing—a peaceful interruption from more mundane activities.

Days started early for Ruth, a woman of slight build whose hands were sculpted from carrying pails of water and chicken mash and from scrubbing clothes on a washboard. "She was tired," recalled her daughter, Virginia Steelman Golly of Zearing. "Everything was hard on the farm. We had no electricity."

Some of Ruth's sewing, like making the children's clothes, was done out of necessity. Some was done out of pride. Ruth loved to embroider, even embellishing feed sacks with colorful, delicately sewn flowers to make attractive tea towels and dresser scarves. She took cloth remnants from sewing and pieced them into quilts for the house, for her children, and sometimes to sell.

Growing up, she had watched her mother, Mary Adams, piece and quilt. Ruth's first quilt was the wild rose pattern in pink. Often she made appliquéd maple leaf pattern quilts. "I grew up with her having quilts set up all winter and summer too," Virginia reminisced about life with her mother. Four dining room chairs were placed in the living room to hold two pieces of wood two and a half inches wide. The wood was wrapped with cloth. Ruth stitched or pinned the backing of the quilt to the cloth and rolled the quilt up as she moved along.

"Each of our beds had a tied quilt," Virginia recalled. "Mother and her sister-in-law and friends would exchange pieces of fabric when they were piecing." Virginia picked up one of the quilts her mother had made—a striking one with appliquéd and exquisitely embroidered purple pansies. The meticulous, time-consuming embroidery work she often incorporated into her quilts became a signature on her quilts.

Virginia easily recalled memories of her mother sewing. "From the time I can remember, she was sewing clothes for me. She had a treadle machine." For a while, her mother and a group of friends got together in each other's homes and sewed, calling their group Stitch and Chatter. Virginia and her sister-in-law, Aina Golly, were invited to join. "I couldn't piece whatever," she said. "I'd love it when they'd get it pieced and in the frame and I could quilt. They had patience with me. Aina remembers the lunches—big hot dishes, lots of stuff, not like salad."

Eventually Ruth began quilting alone at home. She had to sneak needlework and quilting into scarce nonworking moments during daylight. The products of her needlework were like bouquets of fresh flowers in the home. Spring and fall the children returned home to find snacks on the dining room table hidden under one of their mother's hand-stitched lunch cloths. Virginia reminisced, "You were supposed to help yourself. She inherited the idea of the lunch cloth from her mother. I grew up going to Grandma's looking under the cloth. There was always a candy dish with pink wintergreen candies and horehound candy."

Everything on the farm—even the soap—was homemade by Ruth. She made all the bread, and Virginia recalled "trading sandwiches with friends at school to get 'boughten' bread." Her sisters, Bernice and Frannie, had homemade graduation formals. Virginia, being the youngest, got a "boughten" graduation formal. "When my brother Floyd graduated, they said it took a wagon full of corn to buy a graduation suit," Virginia reminisced.

After they moved from the farm into town, Ruth sometimes spent the day at a rustic cabin on the rented farm. She took her embroidery and quilting with her and prepared her husband a hot midday meal at the cabin.

"I always felt we were a typical farm family," Virginia recalled. "We got to town on Wednesday nights to band concerts. Illinois Grove had an ice cream social once a year, and everyone turned out for that. I remember creeping down at corn-picking time and just watching. It would be dark. They would be getting horses ready to go out. It was quite a life. It was a typical farm. We thought we had everything. We were never hungry."

Ruth made sixty-five or seventy quilts in her lifetime. She made three quilts for each of her six children and two each for her ten grandchildren. She sold a few. In the early 1960s, she sold an exquisite rose quilt for twenty-five dollars. Like her first quilt, her last quilt was pink. It was a gift to her great-granddaughter. Ruth died in 1970.

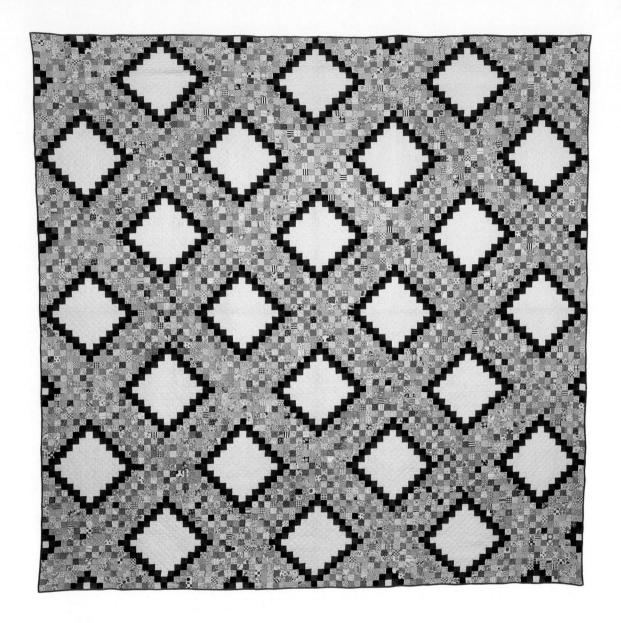

Postage stamp, 1935–1945. Many of the squares in this "sunshine and shadow" postage stamp quilt were taken from fabric samples. Black and red were frequently incorporated into postage stamp quilts during this period. Author's collection. Addison Doty photo.

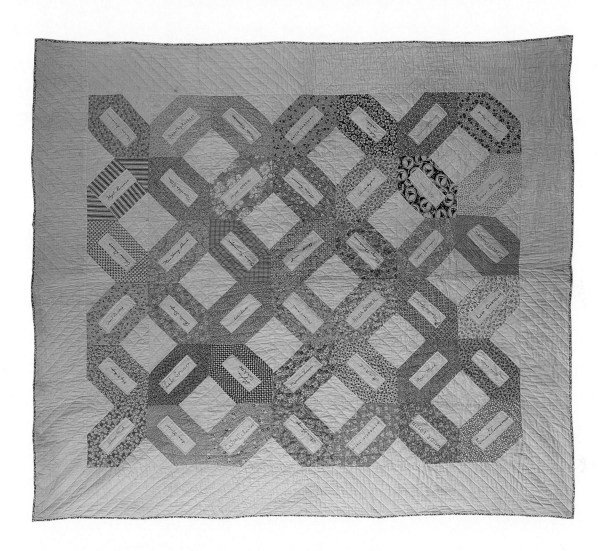

Honeycomb, 1940–1950. The honeycomb pattern was used as a frame for the signatures embroidered on this quilt, which has a background of fine white cotton. It could have been a wedding present or a gift for a minister's wife. Author's collection. Rod VanderWerf photo.

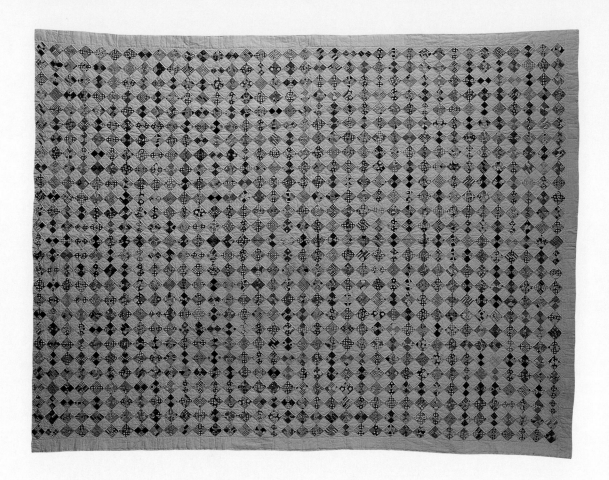

One patch, 1940–1950. Some one thousand squares of fabric were used in this fresh and
pleasing quilt. Author's collection. Rod VanderWerf photo.

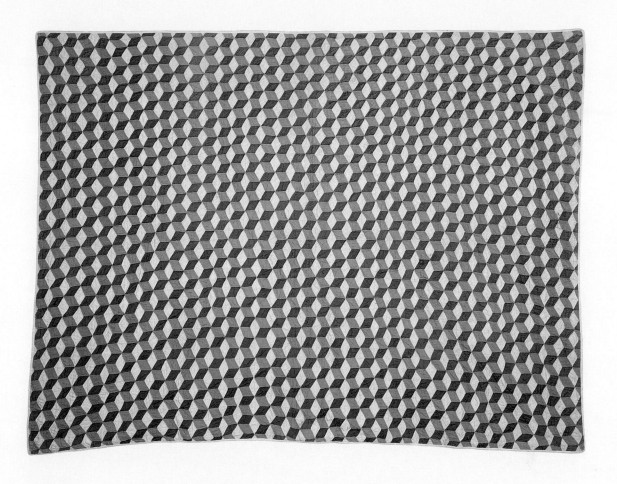

Tumbling blocks, 1945–1955. Ruth (Mrs. Joe) Robinson, Ames, was the creator of this pink, blue, and white quilt of fine cotton sateen. The quilt has a feeling of absolute perfection.

Author's collection. Addison Doty photo.

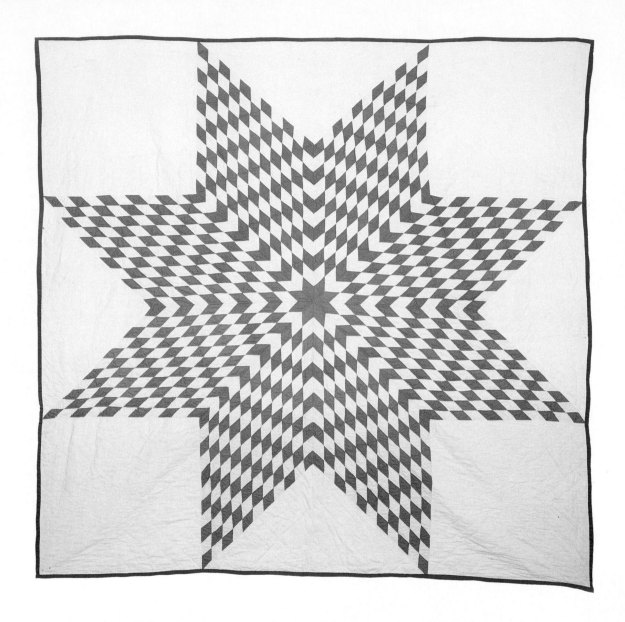

Star of Bethlehem, 1950–1960. This is a two-color variation of the star quilt. The pink and blue triangles against the white background project quietness, although the quilt is complicated because of the necessity to have the triangles match. Author's collection. Addison Doty photo.

The Sunshine Circle

THE SIMPLE rural white-frame church sits hidden on a wooded knoll two left turns on gravel roads from hectic Interstate 80. Bear Creek Friends Meeting House, Society of Friends, is a church without a minister run by a clerk and an overseers' committee. The stillness takes one back from June 2000 to the time of the church's beginning in the 1870s, when the land was homesteaded by Quakers seeking tranquil areas with water and timber.

> On the P.M. of 5th mo, 2nd 1912 a few friends met at Robert Peckham's to consider the subject of organizing a society of some kind. Alice L. Standing being appointed chairman called the house to order.
>
> After some discussion of various plans Edith R. Peckham and Joanna Mott were appointed to draft some rules or by laws for the guidance of the society.
>
> We then adjourned to meet at Chester Mott's the first Fifth day in the Sixth month.
>
> Alice L. Standing, chairman

Wanda Knight, niece of Alice Standing, was in the basement busily setting up quilting work for the monthly meeting of the Sunshine Circle. "We're kinda small," she explained somewhat apologetically. "We got up to thirty-five. We're now down to twelve. Everybody's working. Just a lot of people work. I work too, but I don't work away from home. We're mostly farm ladies. With changes in farming, lots of people go to the city to work now."

The Sunshine Circle met at the home of Joanna Mott on the 11th of 3 mo. (1914) The afternoon was spent in tying comforts for Mr. and Mrs. Weekley on account of their home being burned. The material being donated except the cotton for one comfort, which came to 56 cents to be paid by members of the circle who did not donate material.

During the afternoon a very interesting paper was read by Alice Standing entitled "Lessons from a Life."

Pres. called the meeting to order ten members responded to roll call; report of last meeting was read and approved.

It was decided for the Pres. and Sec. to deliver the comforts and also fruit which was donated. 22 qts. in all. Pres. appointed Alice Standing to act as business committee. Meeting adjourned to meet with Belle Fry. May Curts. Sec.

The Sunshine Circle's years of handwritten minutes on yellowed pages, in hardcover notebooks, carefully explain that fifty attended the picnic in 1919, but "ice cream was omitted and the collection of $3.10 went to buy sewing material." The minutes also reveal that six meetings were missed in 1918 and 1919 "because of the prevalence of Spanish Influenza."

"We make quilts and comforts," Wanda explained. To make the comforts, nine-patch blocks, cut from scraps, are sewn together by hand. Then someone takes the blocks home and sews them together on a machine. The comfort is bound by hand. "The comforts are made by those who don't quilt," she added. "We give comforts to people who have fires or deaths in their family or people who are destitute. If there's a special need, we get together extra times. Sometimes we give two comforts if someone had a catastrophe. At first they did work for folks in poverty," she recalled. "I remember my mom. We'd put the sewing machine in the old Plymouth and take it to Sunshine Circle because we'd be making pajamas and shirts for needy people."

The Sunshine Circle held their annual winter gathering at the home of Marlin and Mary Curts 2nd mo. 3–1917. 57 were present to partake of the

feast that was spread before them. The tables fairly groaned under the weight of good things to eat. A short programme was given in the afternoon and then a talk or short course. A collection of $3.25 cents was taken to pay for muslin and batting for comforts for Christian home. Also to pay freight on goods sent for and for sending comforts to Christian home. Pres. Beulah Renshaw

"They were quilting when I was a little girl in the thirties and forties," Wanda remembered. "We went to people's homes and went from house to house. Now we do as much quilting as we can. It doesn't go very fast. There are only about four quilters left. We make baby quilts for babies with AIDS. We take the quilts to the police station. When they're called to an abused case or needy family, they take them. They keep them in their cars," she mentioned proudly. Money raised from making quilts for members and friends is donated to the Food Bank, to American Friends Service, and to the community. The group helps put on funeral dinners, they visit the sick, and they attend all celebrations.

The Sunshine Circle met March 14 (1934) at the home of Stella Williamson. About 25 members were present.

The placing committee report some bedding and little boys clothes were placed with Lambs, near Dexter, their house burned recently.

A bill of $.25 was allowed to Lydia Standing for yarn and dye.

Lydia and Marie Standing were appointed to take the packages we are giving to Emma and her family.

Meeting adjourned.

Miriam Standing vp

A simple, handmade, pegged wooden quilt frame was in the back of the basement room. It held the beginning of a quilt created from old album quilt blocks Wanda had picked up at an antique show. The women will do the quilting for Wanda. "I will pay them for it when it's done. I think I'll pay $75. If you're a member, you get it a little cheaper.

I learned quilting from my mother. We always had a quilt up at my house. It was real generational. I have one at home and several in my closet I need to do. I don't quilt every day. I like to read too much."

Avis Kenworthy arrived for the day's gathering. She attended her first meeting with her mother-in-law, Verdie Kenworthy, who had joined the Sunshine Circle soon after it started. "She didn't tell me much," said Avis matter-of-factly. "She loved it and enjoyed it."

Alberta Kisling's mother, Lorene Standing, ran the sewing machine for the group for years. Even in her nineties she operated it. "I remember growing up and going to Sunshine Circle," she said. "We'd hide underneath quilts while they quilted."

The room became silent. Herbert Standing, tall, gray-haired, healthy-faced under his cap, walked through the door and stood conspicuously out of the way. The women looked toward him as if anticipating a message. "Mother won't be able to come today, but she'd be happy to have anyone stop by."

His mother is Mildred Standing. A spry and alert hundred years old, she is the group's treasure. "She used to quilt," it is explained. "Now she sews blocks. She doesn't feel like her stitches are small enough."

The Sunshine Circle met 10–13–1943 at the home of Lorene Standing. The second quilt for Fanny Bathurst had been marked and put in the frames before hand, and a good start was made in quilting it. We also helped Elsie tie a comfort. Several quilt blocks were pieced.

The Pres. called the business meeting to order. The minutes of the last meeting were read and approved.

There was some discussion about what sewing we should do, in addition to quilting. Lucy Ellis had asked whether the circle would do part of a quilt for her. The members are willing to do what they can at it.

A collection of $.60 was taken.

Pres. Pauline Jones.

Rec'd from Fanny Bathurst for quilting $4
Collection $.60
Previous balance $13.63

The conversation turned to quilting. "You either like it or don't," explained Helen Hester, tenderly rubbing her hand across a finely stitched part of the album quilt in the frame. "I'm always fascinated with how they turn out. You take something not attractive, and they turn out beautiful." She motioned to the unstitched part of the quilt.

A modern-day farm wife, Helen helps her husband put in crops on the eight hundred acres they farm. In her spare time she sits at the frame set up in her house and quilts for relaxation. She has made a quilt for each of her five children. "Farming isn't like it used to be," she said. "It's high-tech."

Sunshine Circle met November 8, 1950 with Alice L. and Miriam Standing, with Wanda Knight assisting.
 The quilting was finished on the two quilts the circle has been working on, and a comfort was tied. Sewing was done on several garments and quilt block work progressed rapidly. We decided to give the comfort that was tied to a DP family in the county. Pres. Mildred Standing

"I don't like to prick my fingers," said Wanda, wiggling her fingers and grimacing. "My mother put fingernail polish or tape on her fingers. She quilted so much her fingers got raw." She slid her hand underneath the almost silky cotton quilt and gave a demonstration. "You put down the needle and touch your finger underneath. You bring it back up and rock the needle back and forth to get two or three stitches on your needle. 'The smaller the needle, the smaller the stitch,' my mother used to say." Wanda picked up her thimble. "You have to have a thimble. You push the needle with a thimble."

"Some people these days will put something underneath, but that doesn't work for good quilting," Dorothy Weller said. "Some people

like Wanda can quilt in any direction. I can quilt toward me and to the right." Dorothy's grandmother talked her into quilting a quilt and "forced me to finish it. It was part of life. My grandmother, everyone quilted. You were just expected to quilt."

Sunshine Circle met with Pauline Fry March 12 (1958). A potluck dinner was served at noon with an abundance of food.

Mary Curts reports the comfort is finished. The quilt on hand was almost finished and Doris reports of another quilt ready to go in. The day was spent quilting and working on quilt pieces. We enjoyed having Doris with us again and also Marjorie Benson. The next meeting is to be held at Cynthia's.

Sec. Dorothy Standing

The conversation moved to the weekend wedding of Helen Hester's daughter, Lynn. "It was just beautiful," said Dorothy. "They decorated the social hall in the community buildings." Then talk shifted to the days of cleaning milk separators on the farm. "That was the worst job," Avis exclaimed. She explained how conversation works at the meetings. "When we talk about someone, it isn't gossip," she said. "It's caring."

October 8, 1980

About 21 members of Sunshine Circle were present. President Osa Bricker called the meeting to order. Minutes were read and accepted. Treasurer's report showed a balance of $28.59.

Old business: The quilt displayed at last month's meeting was purchased by Elsie Osborn and Osa Bricker for $75.00, that price being acceptable to the group.

The quilt committee suggested charging $30 for the Witt quilt which has been delivered but not paid for. Carol Henderson moved to charge $30. It was seconded and approved.

A comfort has been tied for Jim Price family who lost their home in a fire. Maxi Duesenberg's quilt is finished, and Maxi will set a price for the quilting.

Geri Williamson will send Halloween cards to our kids at Woodward. It was also announced that Ruth Benson will be 98 years old Dec. 8th.

Win Standing invites us to meet in her home for the November meeting.

It was moved and seconded to adjourn.

Margaret Hoge started quilting in 1927 while living in the woods of Florida. "A real 'cracker' lady taught me to sew," she exclaimed. Three years later she moved to Iowa for seminary, nurses' training, and a career in nursing. "I've always been piecing," she said. "I always had scraps cut for a quilt. I worked twenty years and pieced while I worked."

Sunshine Circle met April 13, 1988 at the meeting house. A total of 13 members worked on quilts and baby comforters. 10 enjoyed the noon meal and lemon dessert provided by Hazel Steward and Marie Cook. It was agreed to have an open house at our May meeting to thank former members and to meet some new "possible" members. We will give $50 to AFS [American Friends Service] again this year. Claria Ramsey shared a quilt she made for her son, Glen. All agreed it was a beautiful quilt of browns and blues. Osa shared some "house on the hill" blocks she has pieced for grandchildrens' quilts. A get well note was written to Erma Inman who was ill with flu. A thank you note from Bertha Osborn was read. Jackie Leckband Pres.

Osa Bricker looked up from her work, gazed at the others fondly. "I think it's something Sunshine Circle's lasted so long. I feel like it's part of me."

Sources

✻

Bacon, Lenice I. *American Patchwork Quilts*. New York: William Morrow, 1973.

Bishop, Robert, and Carleton L. Safford. *America's Quilts and Coverlets*. New York: Dutton, 1972.

Clarke, Mary Washington. *Kentucky Quilts and Their Makers*. Lexington: University of Kentucky Press, 1976.

Finley, Ruth. *Old Patchwork Quilts and the Women Who Made Them*. Boston: Charles T. Branford Co., 1929.

Hall, Carrie, and Rose G. Kretsinger. *The Romance of the Patchwork Quilt in America*. 3 vols. Caldwell, Id.: Caxton Printers, 1935.

Holstein, Jonathan. *The Pieced Quilt: An American Design Tradition*. Greenwich, Conn.: New York Graphic Society, 1973.

Huff, Mary Elizabeth Johnson. *A Garden of Quilts*. Birmingham, Ala.: Oxmoor House, 1984.

Ickis, Marguerite. *The Standard Book of Quilt Making and Collecting*. New York: Dover Publications, 1949.

Kiracofe, Roderick. *The American Quilt: A History of Cloth and Comfort, 1750–1950*. New York: Clarkson Potter, 1993.

Khin, Yvonne M. *Collector's Dictionary of Quilt Names and Patterns*. Washington, D.C.: Acropolis Books, 1980.

Lasansky, Jeannette. *In the Heart of Pennsylvania: 19th and 20th Century Quiltmaking Traditions*. Lewisburg, Penn.: Oral Traditions Project of the Union County Historical Society, 1985.

Peto, Florence. *American Quilts and Coverlets: A History of a Charming Native Art*. New York: Chanticleer Press, 1949.

Smith, Michael O. "Heartland Comfort: Bedcoverings from the Collection of the State Historical Society of Iowa." *Iowa Heritage Illustrated* 80, nos. 1 and 2 (Spring/Summer 1999): 34–93.

Webster, Marie D. *Quilts: Their Story and How to Make Them*. Garden City, N.Y.: Doubleday, Page and Co., 1915.

Index

✻

Pages with illustrations are italicized.

Adams, Mary, 118
Adams, Ruth. *See* Ruth Adams Steelman
Albia, 1
album quilts, 21, *47*, *94*
Allerton, 89
Amana Colonies, 85
American Friends Service, 127, 131
American Quilt Society, 69
Ames, xii, 22, 23, 25, 123
Amish, 43–47, 79, 80, 85, 97–100
Anderson, Carrie, 112
Andre, Alice Fox, ix, xi, xii, 63
Anna's choice, *83*
appliquéd quilts, 1, 2, *7*, *8*, *9*, 15, *18*, *19*, *20*, 68, *73*, 89, *92*, *93*, *102*, *104*, 110, 118
Asher, Donald, 2–4
Asher, Dortha, 1–4
Attica, 1
autograph quilts, xiii, *47*, *94*, *121*

Backsen, Malura Alyn Bower, 12, 13, 14
Ball, Anna Isabel Calhoun, 12
Ball, Edith. *See* Edith Ball Bower
Ball, Elsie Noble "Nobly," 11–15
Ball, Frank, 12
Ball, Mary. *See* Mary Ball Jay
Ball, Smith, 12
Backsen, Malura Alyn Bower, 12, 13, 14

Barbara Fritchie star, *8*
Barton, Arthur, 23
Barton, Mary Premble, 21–25
Barton, Tom, 22, 25
basket of flowers quilt, *72*
Baston, Rose, 94
Bathurst, Fanny, 128, 129
Bear Creek Friends Meeting House, xiii, 125–131
beige-on-beige quilt, 56
Benson, Marjorie, 130
Benson, Ruth, 131
Bernard, Jennifer, 54, 55
bird lover's guide quilt, 15
bluebells quilt, *104*
Bontrager, Gary, 45
Bontrager, Joe, 45
Bontrager, Karen, 45
Bontrager, LaVon, 45
Bontrager, Marlin, 45
Bontrager, Mary, 45
Bontrager, Merle, 45
Bontrager, Salina, 43–46
Bontrager, Wanda, 45
Bontrager, Wayne, 45
Boone, 77
Bower, Edith Ball, 12
Bower, Malura Alyn. *See* Malura Alyn Bower Backsen

bread basket quilt, *74*
Brewton, Cecil, 35–36
Brewton, Frances, 33–36
Bricker, Osa, 130, 131
broken dishes quilt, *30*
Bussey, 1

cactus rose quilt, *7*
Calhoun, Anna Isabel. *See* Anna Isabel
 Calhoun Ball
Calhoun, Malura. *See* Malura Calhoun
 Sens
capital "T" quilt, *17*
Carolina lily quilt. *See* prairie lily quilt
Cedar Falls, 9, 71
Cedar Rapids, 35, 107
Celtic quilting, 4
Charles Lindbergh quilt, 105
cherries quilt, *73*
cherry basket quilt, *81*
chimney sweep quilt, *47*
Christenson, LaVonne, 112
Christeson, William, 54
Chupp, Barbara, 43–46
Chupp, Menno, 44
Chupp, Salina. *See* Salina Bontrager
Civil War quilt, *71*
Cleveland's choice quilt, *31*
Clow, Mrs. Archie, 14
Collinsville, 34
colonial basket quilt, 23
computer software for quilting, 69
Cook, Marie, 131
Corwith, 79
Corydon, 87, 89
crazy block quilt, *84*
crazy quilts, xiii, *61*, *84*, 107, 110
cross-stiched quilts, xii, 53–54, 110

Crouse, Mary Alice. *See* Mary Alice
 Crouse Lisle
Crouse, Mary Stephens, 21
Curts, Marlin, 126
Curts, Mary, 126, 130

Davenport, 35, 77–78, 107, 108, 111
Des Moines, 22, 23, 33, 35
Des Moines Quilters Guild, 35, 89
Desert Storm quilt, 25
Dexter, 127
dogwood blossom quilt, 68
double wedding ring quilt, *106*
Dresden plate quilt, xii, xiii, *113*
drunkard's path quilt, *52*
Dubuque, 61
Duesenberg, Maxi, 130

Earlham, xiv, 125–131
Echelberger, Robert, 53–56
Echelberger, Russell, 55
Echelberger, Sadie, 53–56
Echelberger, Shirley, 54–55
Echelberger, Tom, 55
Ellis, Lucy, 128
Estes, Otto, 11
Estherville, 34

Fairbank, xiv
Fairfield, 12–15
fan quilts, xiii
feathered star quilt, *16*
Festival of American Folk Life, 36
flower appliqué quilt, *93*
flower basket quilts, xiii, 108
flower garden quilts, 88, 109
flower pot quilt, *9*
Fluidt, Mrs. John, 11

fly foot quilt, *95*
flying geese quilt, 21
four patch quilt, 98
fruit basket quilt, 4
Fry, Belle, 126
Fry, Pauline, 130

geometric design quilt, *20*
Gibson, David, 86
Gibson Furnaces quilt, *86*
Golly, Aina, 118
Golly, Virginia Steelman, 117, 118, 119
Grand Junction, 88
grandmother's fan quilt, *114*
Graves, Eva, 6
Graves, Susan Smith, 6
Grout Museum, 56, 80

Hamilton, 1
Hartford star quilt, 55
hearts and gizzards quilt, *65*
Henderson, Carol, 130
Hennis, Martha Agnes, 114
heritage quilt, 23–24
Hester, Helen, 129, 130
Hester, Lynn, 130
hexagon quilts, 109–110
Hoge, Margaret, 131
honeycomb quilt, *121*
hovering hawks quilt, *39*

Illinois Grove, 117, 119
Independence, 103
Indianola, 22
Inman, Irma, 131
International Center for Rural Culture, 89
Iowa City, 35

Iowa Quilters Guild, 56, 70, 89
Iowa State Fair, 68, 69
Iowa State University, 22, 23, 70

Jacobson, Don, 67
Jacobson, Helen, 67–70
Jacobson, Larry, 70
Jay, Carl, 12
Jay, Mary Ball, 11–15
Jefferson County, 12, 15
Johnson, Ivan, 77–80
Johnson, Mildred, 78
Johnson, Ruth, 77–80
Jones, Pauline, 128
Jordan, Ethel Taylor, 87–90
Jordan, Ralph, 88

Kalona, 24, 44, 45, 46, 80, 97–100
Kalona Historical Society, 45
Kalona Kountry Kreations, 97–100
Kenworth, Verdis, 128
Kenworthy, Avis, 128, 130
Kisling, Alberta, 128
kit quilts, 68
Knapp, Eva Graves, 6
Knight, Wanda, 125–127, 129
Kossuth County, 77

Ladies Aid Society of the St. Anthony
 Christian Church, 94
Lamb family, 127
Le Claire, 88
Leckband, Jackie, 131
Licke, Edward, 77, 78
Lisle, Mary Alice Crouse, 21, 22
log cabin quilts, xi, xii, *6, 27, 28, 29, 62, 63*
lone eagle quilt, *105*
love apple quilt, *18*

Lovilia, 2

maple leaf quilts, 118
mariner's compass quilt, *10*
Marysville, 1
Mason City, 53, 54
Maxwell, 67, 68
McClintock, Elizabeth, 5
McClintock, Sara Jane, 5
Mead, Mr., 8
Mehlisch, Dorothy, 114
Mennonites, 98, 100
Middletown, 88
Miller, Sara, 24, 97–100
Minerva, 114
miniature quilts, 69
Mississippi Quilters Guild, 108
Missouri puzzle quilt, *37*
monkey wrench quilt, *59*
Moravia, 1
mother's fancy star quilt, *58*
Mott, Chester, 125
Mott, Joanna, 125, 126

National Bicentennial Quilt Contest, 24
New Sharon, xii, 63
nine patch quilts, *38*, *85*
North Iowa Fair, 56

ocean waves quilt, *49*, *50*
Ogden, 77
Ohio lily quilt. *See* prairie lily quilt
one patch quilt, *122*
Osborn, Bertha, 131
Osborn, Elsie, 130

Panora, 21
Peckham, Edith R., 125

Peckham, Robert, 125
Petersen, Vincent, 107
Petersen, Winnifred Tyerman, 108–111
Peterson, Lora Beth, 111
Pennsylvania Dutch, 19
Pennsylvania tulip quilt, *5*
pine tree quilt, *112*
plain-top quilts, 46
Pomeroy, 107
postage stamp quilt, *120*
prairie lily quilt, *41*
Premble, Bill, 24
Price, Jim, 130

Quakers, 117–119, 125–131
quilling, 56

rail fence quilt, *57*
rambler quilt, *75*
Ramsey, Claria, 131
Ramsey, Glen, 131
Renshaw, Beulah, 127
Ricke, Edward, 77
robbing Peter to pay Paul quilt, *52*
robin quilt, 15
Robinson, Ruth, 123
Roland, 112
rose quilts, *7*, *19*, *92*, *102*, 118
Round Prairie Township, 12
Rownd, Mrs. Samuel, 9

Saint John's Lutheran Church, 108
Saint Petri Lutheran Church, 24
Sampson, Bertha, 112
Scott Community College, 108
schoolhouse quilt, *66*
Selection Aid, 3
Sens, Malura Calhoun, 12

shadow quilting, 4
Sheckler, Mrs. Russell, 15
shoo fly quilt, 13
Short, Carrie, 11
Simpson College, 22
Smith, Susan. *See* Susan Smith Graves
Smithsonian Institution Center for Folk
 Life, Progress, and Cultural Studies, 36
snowball quilt, *26*
snowflake quilt, 2
Society of Friends, 125
Standing, Alice L., 125, 126, 129
Standing, Dorothy, 130
Standing, Herbert, 128
Standing, Lorene, 128
Standing, Lydia, 127
Standing, Marie, 127
Standing, Mildred, 128, 129
Standing, Miriam, 127, 129
Standing, Win, 131
star quilts, *8, 16,* 34, *51,* 55, *58, 60,* 89, 91, *101,*
 115, 124
star of Bethlehem quilts, *101, 124*
star upon stars quilt, *91*
State Historical Society of Iowa, 24
Steelman, Bernice, 119
Steelman, Floyd, 119
Steelman, Frannie, 119
Steelman, Otis, 117
Steelman, Ruth Adams, 117–119
Steelman, Virginia. *See* Virginia Steelman
 Golly
Stephens, Mary. *See* Mary Stephens
 Crouse
Steward, Hazel, 131
Stewart, Dr., 13
Stitch and Chatter sewing group, 118
Storm Lake, 107

Story City, 24
Story County, 67
streak of lightning quilt, *40*
Strong, Sara, 18
sunburst quilt, *10*
sunrise quilt, *116*
sunshine and shadow quilt, 120
Sunshine Circle, xiv, 125–131
sunshine memory quilt, 24–25

Taylor, Ethel. *See* Ethel Taylor Jordan
tree everlasting quilt, 24
triple Irish chain quilt, *64*
tulip quilt, *82*
tumbling blocks quilt, *123*
Turpien, Mr., 35
Tyerman, Winnifred. *See* Winnifred Tyer-
 man Petersen

University of Iowa, 35

Vanderheyden, Clara Belle, 62
Vaughan, Ruth. *See* Ruth Johnson
variable star, *51*
vine patch quilt, 11
Virginia star quilt, *115*

Walker, Lillian, 15
Waterloo, 8, 86
Wayne County, 87, 89
wedding ring quilts, xiii, 11
Weekley, Mr. and Mrs., 126
Weller, Dorothy, 129
Wesley, 77
white quilts, 46, *103*
Williamson, Geri, 131
Williamson, Stella, 127
Winnebago Company, 78

Women's Christian Temperance Union, 17

wood lily quilt. *See* prairie lily quilt, 41

Zearing, 112, 117

Other Bur Oak Books of Interest

The Folks
By Ruth Suckow

An Iowa Album
A Photographic History, 1860–1920
By Mary Bennett

Iowa Stereographs
Three-Dimensional Visions of the Past
By Mary Bennett and Paul C. Juhl

Letters of a German American Farmer
Jürnjakob Swehn Travels to America
By Johannes Gillhoff

Neighboring on the Air
Cooking with the KMA Radio Homemakers
By Evelyn Birkby

Nothing to Do but Stay
My Pioneer Mother
By Carrie Young

Picturing Utopia
Bertha Shambaugh and the Amana Photographers
By Abigail Foerstner

Prairie Cooks
Glorified Rice, Three-Day Buns, and Other
 Reminiscences
By Carrie Young with Felicia Young

Prairie Reunion
By Barbara J. Scot

A Ruth Suckow Omnibus
By Ruth Suckow

Sarah's Seasons
An Amish Diary and Conversation
By Martha Moore Davis

State Fair
By Phil Stong

The Tattooed Countess
By Carl Van Vechten

Vandemark's Folly
By Herbert Quick

Weathering Winter
A Gardener's Daybook
By Carl H. Klaus

The Wedding Dress
Stories from the Dakota Plains
By Carrie Young